D0813683

SEARS
IN CHICAGO

SEARS
IN CHICAGO

A Century of Memories

Val Perry Rendel

THE
History
PRESS

Published by The History Press
Charleston, SC
www.historypress.com

Front cover: The Sears Tower, 1980. *Library of Congress*.
Back cover: Library of Congress; top insert: Billy Stone's raising gang sets the last beam atop the 110th floor of the Sears Tower, May 3, 1973. Pictured: Ed Kelly (*far left*) and Tommy Stack (*second from left*). *Photo courtesy of Richard Gumber and Scott Rowell; left insert*: *Library of Congress*; *right insert*: *Northwestern University Archives*.

First published 2019

Manufactured in the United States

ISBN 9781467139946

Library of Congress Control Number: 2019935357

Notice: The information in this book is true and complete to the best of our knowledge. It is offered without guarantee on the part of the author or The History Press. The author and The History Press disclaim all liability in connection with the use of this book.

To my parents, Donald and Patricia Perry, who lived the glory days of Sears.

CONTENTS

Acknowledgements 9
Introduction: The End of an Empire 13

PART I: FROM CATALOG TO COUNTER (1887–1969)
1. Sears: The Man and His Catalog 19
2. Julius Rosenwald: The Greatest Philanthropist
 You've Never Heard Of 33
3. The Great Works 40
4. The End of the Beginning 47
5. Sears Modern Homes 50
6. Sears Takes to the Airwaves 64
7. The Retail Revolution 70
8. Sears and the Century of Progress 78
9. Sears Goes to War 82
10. Postwar Expansion: The Malling of America 84
11. The Golden Age of Sears 96

PART II: RISE AND FALL (1970–2018)
12. The Sears Tower 101
13. What Happened to Quincy Street? 103
14. Sweet Home Chicago 105
15. "The Brass Ring" 107
16. A Tall Order 109

17. Cowboys of the Sky 114
18. Close Calls 119
19. Tragedy 122
20. Topping Out 126
21. Moving Up 132
22. Calder's *The Universe* 134
23. Mayor of the Sears Tower 135
24. Your Friendly Neighborhood Spider-Dan 136
25. "Anything Is Peaceful from 1,353 Feet" 137
26. Everything Must Go 139
27. Prairie Stone 142
28. The Book Closes 144
29. Where Are They Now? 149
30. Life After Sears 157

Notes 161
Bibliography 165
Index 169
About the Author 173

ACKNOWLEDGEMENTS

No one ever reads the Acknowledgements, so there's a good chance you're not reading this now. But first and foremost, I suppose I should thank Sears. My mom and dad met while working in the Merchandise Building at the headquarters on Homan Avenue in Chicago in 1966. If not for that fortunate event, I might never have existed and would not have had the fun and pleasure of writing this book, which you would not be holding in your hands at this moment.

Other people without whom this book would not exist include:

Karen Widi of Skidmore, Owings & Merrill LLP, for providing images and answering many questions;

Leif Selkregg, who connected me with David Crowell, David Hoffman and Richard Tomlinson, all invaluable resources for the Sears Tower chapter and all with a delightful knack for storytelling. They unanimously remembered the late Richard Halpern fondly and credited his vision for the success of the Sears Tower project;

Photographers Martin Gonzalez, Walter Kadlubowski, Mike Kalaznik, Andre Van Vegten, Rick Drew, Frank Martinek and Stephanie Barto, for their kind permission to reproduce their amazing photos;

The patient and helpful staff at the Northwestern University library in Evanston, Illinois—Peter Burtch, Justin Navidzadeh and Carol Anthony—

for helping me navigate through a century of Sears catalogs in their microfilm archives;

The Hillside Historical Society in Ohio, for its kind permission to reproduce the photo of the last household use for many a Sears catalog;

Lisa Loebig, communication manager at Sears Holdings, was of great help in placing my call for retiree stories in the December 2017 newsletter. Without her assistance, I never would have made contact with Dennis Mele or Robert Judd, both of whom provided valuable material by sharing their experiences of working at Sears;

Ryan and Susan Julian, who met while working at the Six Corners Sears and who shared some fond memories with me on its last day;

Lauren Russell of Antique Home (www.antiquehome.org), for her kind permission to reproduce high-quality images of Sears Honor-Bilt homes;

Lara Solonickne, for her excellent presentation on Sears Kit homes at College of Dupage and for her generosity in allowing use of images from her blog, *Sears Homes of Chicagoland*: http://www.sears-homes.com;

Kevin P. Coleman and the members of the Ironworkers Local 1 Retirees group on Facebook, for their reminiscences and help with identifying people for photo captions;

Scott Rowell, for his boundless enthusiasm for anything and everything about the Sears Tower and for sharing some amazing photos. Without his decades-long passion for chronicling the stories of the Sears Tower, this would have been a much shorter (and less interesting) book. Scott also provided priceless reminiscences about the late Ray Worley, the late Richard Gumber and the late Leroy Brown. Last but not least, he got me in touch with ironworkers John Porzuczek and Vic Mugica, who also generously shared memories of constructing the world's tallest building;

Jo Ann DeKlerk, for allowing me into her home and crawlspace and for being endlessly patient during the endless process of scanning photos. The images of the Sears Tower topping-out ceremony are simply incredible and appear here in print for the first time;

Mrs. Hilda Wiggins and her daughter, Amy, for their willingness to contribute important information and for sharing their story. The families who lost loved ones in the building of the Sears Tower were courageous enough to go down some difficult roads in order to share memories with a stranger, and I am humbled and honored by their generosity. They deserve recognition, and I hope I have done their stories some justice here;

Ben Gibson, my commissioning editor, for always being willing to lend a patient, guiding hand and for his generous flexibility with deadlines;

My husband, Allen Rendel, for running to the library, reading drafts, exploring cemeteries, providing IT support at literally all hours, giving a much-needed assist with placing and captioning images and generally being the best father in the world and doing all the things;

And my parents, for inspiring this project, assisting with editing and providing invaluable in-the-moment accounts of Sears in the 1960s.

Introduction

THE END OF AN EMPIRE

It's a Sunday afternoon in July 2018, and I am standing in the last Sears store in Chicago.

This four-story building at the Six Corners intersection in the city's Portage Park neighborhood was among the first to incorporate Sears's iconic windowless tower design, inspired by the art deco structure the company had displayed at the 1933 Chicago World's Fair. Now the front doors—the only glass in the building—are pasted over with red-and-yellow banners that scream "FINAL SALE! STORE CLOSING! EVERYTHING MUST GO!" Beneath these, a smaller blue-lettered sign invites customers to "Come join our team!"

On the day of this store's grand opening in 1938, nearly 100,000 people passed through these doors.[1] There aren't quite that many here now, of course, though it's barely controlled chaos nonetheless. The security alarm is blaring, but no one seems to care. A sea of people presses against the checkout counters, even though all the bargains have been snapped up long ago. All that remains are a few winter pajama sets, pom-pom hats and some area rugs. Many of the light fixtures have been carted off by enterprising local business owners, along with clothing racks, dress forms and wall mirrors. A single green chenille jacket hangs sadly from an otherwise-stripped end display.

Not everyone is here to shop, however. Many are here to say goodbye to the store that is interwoven with some of their most precious memories. A man is filming his young son as they walk through the store, recording their final visit for posterity. Ryan and Susan Julian are revisiting the site of their

first meeting forty-six years ago. He was a management trainee in the lamps and curtains department, and she was in high school working part time as a salesclerk. One evening, toward the end of their shift, the department manager asked Ryan if he wouldn't mind giving Susan a ride home...at the same time telling Susan that Ryan had offered her a ride. Neither of them figured out what had happened until later. They married in 1974, and although both moved on to different careers, Sears still holds a special place in their hearts and always will.

In less than three minutes of conversation with the Julians, we discover more Sears connections between us: Susan's uncle also worked at the company headquarters at Homan Avenue, where my parents met in 1966. As newlyweds, they often shopped at the Sears store on Western Avenue, where Susan's cousin also worked. Connections like this can and do happen in any city, with any store, but in Chicago, the Sears family sentiment still runs surprisingly deep. After all, the city and the store had more than a century of history together and provided tens of thousands of local jobs in its retail stores and catalog. Even today, most Chicagoans know someone who works—or once worked—at Sears.

"Whenever you went to a cocktail party and people asked where you worked, they were impressed when you said, 'Sears,'" my mom recalls. "People respected it."

"You said it with pride," my dad adds. "Back then, a job with Sears was a job for life."

I grew up, quite literally, on this idea. My mom had been a secretary in Department 630 (paint and wallpaper) when she met my dad, a catalog order buyer for all thirteen operations centers spread across Sears's five geographic regions. They both continued working at the Sears headquarters complex on Homan Avenue after they got married in 1966, until my mom left to raise me (after registering for baby gifts at...Sears, where else?).[2] In researching this book, I was delighted to realize that I had actually been present at the Sears Tower topping-out ceremony (described in chapter three), four months before I was born.

We were a Sears family. Everything in our house—all our linens, dishware, appliances, tools, furnishings and electronics—came from Sears. The toys we unwrapped on Christmas morning were carefully chosen from the pages of the Sears Wishbook after hours (if not days) of deliberation. There was something magical about knowing that our dad was somehow connected to secret, endless supplies of toys. Sometimes dad brought home samples that the sales reps had given him, which is how I built my pocketknife collection.

I loved listening to my dad's stories of work. By the time I was eight years old, I had a rough idea of how the supply chain worked and listened eagerly as he talked about buying and distribution meetings. Whenever our family walked into a Sears retail or outlet store (which we did almost every weekend), there was an immediate sense that we belonged here. We were among the privileged inner circle: we got a *discount*.

Of course, we were far from the only ones. "Sears was part of the American fabric," recalls Dennis Mele, who worked as a Division/Sales manager from 1971 to 2005. "Everyone had a connection. That was even more evident in Chicago; Sears was totally in sync with the hardworking, everyday life of the people of this city. It was just a good fit."

"Sears was Amazon," says University of Chicago business professor James Schrager. "The catalog was the internet of the day."[3]

Ironically, it was Amazon.com and big-box stores like Target and Walmart that eventually beat Sears at its own game. When this store closes at the end of the evening, once the lights are off and the doors are locked for the last time, Sears will be gone forever from the city of its birth. For those of us who remember the role it once played, it will live on in memory. But even memories fade over time and are forgotten. Unless we remember.

There is no question that Sears "has left a huge footprint on the city," as Chicago History Museum chief historian Russell Lewis puts it.[4] I began writing this book as a way to put a magnifying glass to that footprint and to inspire readers to dig for more Sears history around the city. Something happened along the way, though: I found myself reliving my own family's uncertain times after my father—along with 49,999 other Sears employees nationally—was forced out when Sears closed its catalog in 1993. I talked to countless Chicagoans whose lives were shaped by the store and its catalog. I came to realize that the story of Sears in Chicago is the story of my family and thousands of other Chicago-area families like us. Ours is a story of invention and reinvention, birth and death, risk, reward and failure. Above all, it's a story about the love a city and a store once shared. And like all great love stories, this one has a tragic ending.

The legacy of that love is what this book is really about. Come explore what Sears, Roebuck and Company gave to Chicago and its people, and what it has left behind.

PART I

From Catalog to Counter (1887-1969)

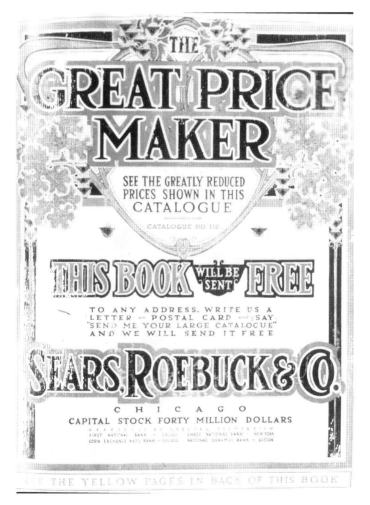

Sears catalog, circa 1910. *Northwestern University Archives.*

1

SEARS

The Man and His Catalog

Quick, who was the most widely read American writer at the turn of the twentieth century? If you guessed Mark Twain or L. Frank Baum or Zane Grey…well, you're way off. It was a young man from Stewartville, Minnesota, whose work never appeared in literature courses or won critical acclaim. His words, however, shaped the lives of millions of Americans and built the city of Chicago into the place where dreams came from.

On the first day of March 1887, Richard Warren Sears stepped out of a Chicago train station at the corner of Canal and Monroe Streets. He stood for a moment, taking in his new surroundings; the station, like most of the city, was fairly new. The Great Fire of 1871 had been an opportunity to re-plan and rebuild most of the streets, structures, parks and promenades. The cooking from dozens of cafés and restaurants—Italian, Swedish, Polish, Hungarian, Czech, Bohemian—cast a haze of greasy smoke that mingled with the smells of horse droppings in the street and sewage from the river below. To Richard Sears, it looked like a land of golden opportunity.

At twenty-four, Sears had already demonstrated "an uncanny knack for writing folksy, down-to-earth, one-person-to-another advertising copy that appealed strongly to rural, small town America."[5] A year earlier, he had bought a shipment of gold watches "mistakenly" sent to the railway depot in Redwood Falls, Minnesota, where he worked as an agent. He advertised them in letters to other station agents and sold them all within six months, even sending for more watches to fill the orders pouring in. Sears knew that Chicago, a sprawling nexus of railways and shipping

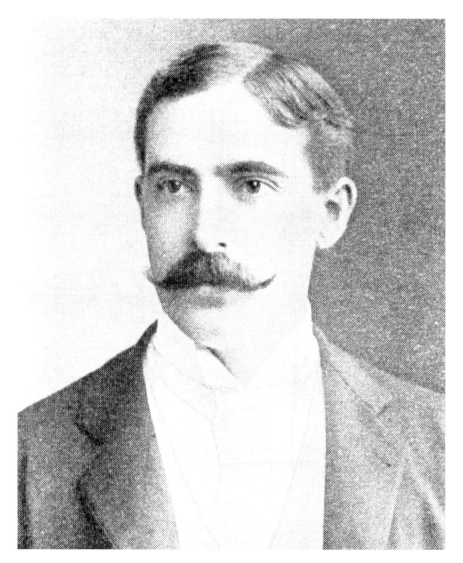

Richard Sears, 1895. *Library of Congress.*

lanes, "Player with Railroads and Freight Handler to the Nation," was the ideal location for any mail-order business.

"Make no little plans," Chicago city planner Daniel Burnham reportedly said; "they have no magic to stir men's blood." Now young Mr. Sears had arrived in the city with $5,000 in capital and big plans. The first step in those plans was to find offices to set up headquarters. Sears turned up the collar of his coat against the sharp March wind and headed east.

THE R. W. SEARS WATCH CO.

Manufacturers, Jobbers and Importers of

Watches, Diamonds and Jewelry,

51, 53 and 55 Dearborn Street,

CHICAGO, ILL.

R.W. Sears Watch advertisement. *Northwestern University Archives.*

WONDER OF THE 19th CENTURY!

THE GREATEST CALENDAR WATCH EVER MADE!

25 PER CENT BELOW ANY OTHER HOUSE IN AMERICA!

We furnish this Watch in either Coin Silver Cases, or 14 Karet Gold Filled, as desired.

Solid Coin Silver, $14.95.
14 Karet Gold Filled, 19.85.

Works automatically; gives the time of day to the second; gives the day of the week; gives the day of the month; gives the year; gives the changes of the moon; all as accurately as a $500.00 CALENDAR WATCH.

THE COIN SILVER CASES are Solid Coin Silver, 900 fine, open face, stem-wind and stem-set, beautifully engraved by hand and warranted in every respect.

THE GOLD FILLED CASES are 14 Karet Gold Filled, made of two plates of Solid Gold over composition metal and warranted to wear for 15 YEARS. *A Guarantee is sent with each watch.* The case is open face, stem-wind and stem-set, beautifully engraved by hand.

THE MOVEMENT is one of the very finest imported movements made, in fact it is one of the finest pieces of mechanical ingenuity yet produced. SOLID NICKEL, full ruby jewels, quick train, patent escapement, patent day, week, month, year and moon calendar, accurately regulated and adjusted and warranted for 5 YEARS.

Our Same Liberal Terms on this Watch!

We will send this watch to any one C. O. D. subject to examination, you can examine it at the express office and if found perfectly satisfactory pay the agent our price and take the watch, but if not perfectly satisfactory REFUSE IT AND DON'T PAY A CENT.

No. 6444.

Be sure to say whether you wish the Silver or Gold Filled Watch.

The greatest watch ever made! *Northwestern University Archives.*

Richard Sears had gone into the watch business just as the railroads had divided the country into four standard time zones. The secret to Sears's success was simple: he knew how to sell things. From the offices of the R.W. Sears Watch & Supply Company on Dearborn Street in the heart of the city's thriving commercial center, he promised his customers 100 percent satisfaction or their money back. He also put his flair for showmanship to good use. When a trolley conductor accidentally dropped his watch and smashed it, Sears presented him with a new one, saying, "We guarantee our watches not to fall out of people's pockets and break."[6] Who could resist a guarantee like that?

Sears always considered this money-back guarantee to be one of his most successful "schemes"—a word he used to mean an incentive in the form of a promise or special offer, such as free merchandise to retailers who handed out the Sears Catalog to customers. These weren't simply sales gimmicks; Sears was determined to earn the trust and loyalty of farmers who were rightly cautious about sending their hard-earned money to a city slicker they didn't know in exchange for goods they had never seen. Plenty of mail-order companies were springing up all over the country, all promising to

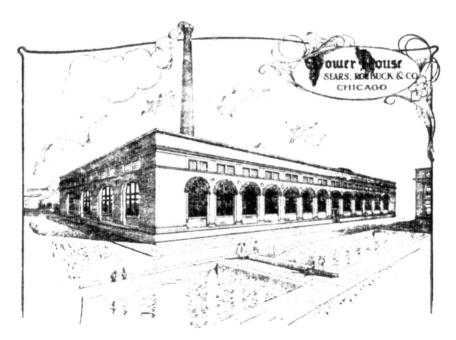

The Power House, pictured in the 1915 Sears Catalog. *Northwestern University Archives.*

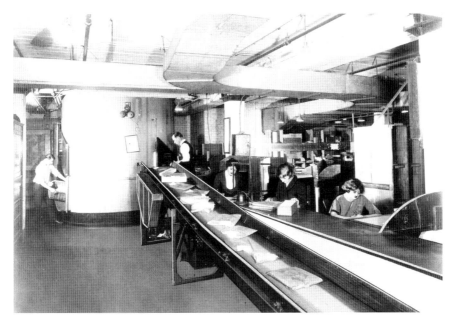

Up to thirty thousand catalogs came off the printing presses every day. *Library of Congress.*

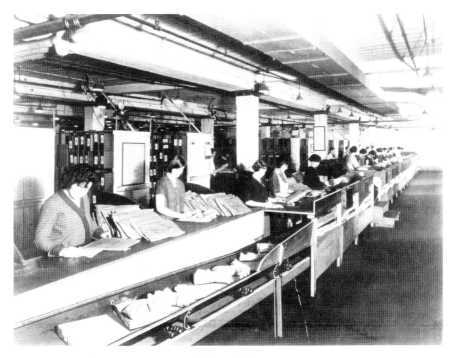

Another image of the printing presses. *Library of Congress.*

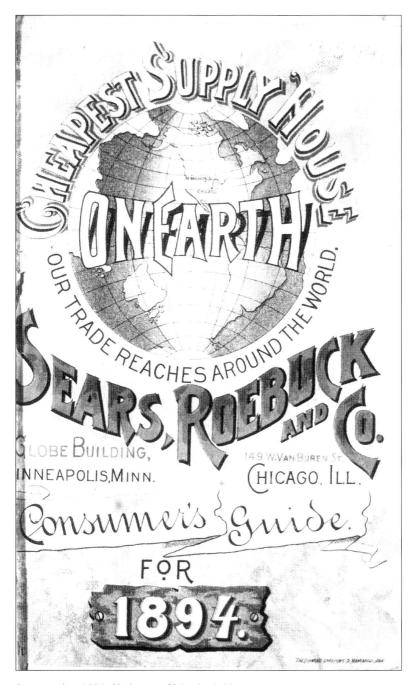

Sears catalog, 1894. *Northwestern University Archives.*

cut out the dreaded middleman. Many charged hidden shipping fees, while others might gladly take your money and send nothing, cancel newspaper advertisements and disappear. Sears's easygoing writing style reassured customers that his was indeed a legitimate and honest business that listened to and cared about them.

Of course, it was much more economical to repair watches than to replace them. But Sears didn't know anything about watches and didn't intend to learn. For this, he hired a quiet watchmaker from Hammond, Indiana, whose name—Alvah Curtis Roebuck—would soon become forever linked with his own.

Mail order isn't a uniquely American enterprise, but American westward expansion gave it a unique place in history. When Chicago-based Montgomery Ward issued its first one-page sales flyers in 1872, it wasn't long before American retailers discovered that the gold out west lay not in the hills, but in selling essential goods and simple luxuries to farmers in rural areas. Ward deserves credit for spotting an opportunity to leverage a fairly simple principle: normally, manufacturers produce goods in large quantities. Wholesalers buy those goods and break them into smaller units to sell at a profit to retailers, who in turn mark up the price to customers.

But what if you cut out the wholesaler? What if the retailer bought directly from a manufacturer and sold directly to the customer at only a small markup? If you were selling only a few things to only a few people, you'd be sure to lose money. You'd have to sell a *lot* of things to a *lot* of people if you were going to make a profit. You would have to know how to reach millions of Americans in the vast rural plains and desert and wetlands and mountains. And you would have to have a practical knowledge of how to use the railroads to get the merchandise to them.

Sears knew all of that. "And he knew that, if he bought in huge quantities, and printed vast numbers of catalogs, and got them to every corner, that he was going to make out like a burglar," says historian Joan Severa. "And that is exactly what happened."

Supposedly, Sears slammed his hand on the Montgomery Ward Catalog and exclaimed, "That's the business I want to get into—the biggest game in the United States today!"

"Richard Sears was probably one of the great promotional geniuses in American business history," said James C. Worthy, former president of the Sears-Roebuck Foundation. "Most farm homes in those days had both a

Left: Sears offered a wide range of specialty catalogs in addition to its Big Book. *Northwestern University Archives*.

Below: Early advertisement for Sears, Roebuck & Co., 1896 catalog. *Northwestern University Archives*.

Sears took its guarantee of customer satisfaction very, very seriously. *Northwestern University Archives*.

Not the tallest in the world…yet. *Photo credit: Stephanie Barto.*

Montgomery Ward Catalog and a Sears Catalog. Richard Sears deliberately made his catalog smaller so that, sitting on the living room table, the Sears Catalog would always be on top."[7]

Catalog copywriting came naturally to Sears. He had written every word of the first small R.W. Sears Watch & Supply Co., then a thirty-two-page catalog for the A.C. Roebuck Company in 1891. Now, in deliberate contrast to Ward's formal style, Sears used a friendly, folksy tone that included touches of humor such as, "If you don't find it in the index, look very carefully through the entire catalogue."

Inside the covers lay a trove of goods that ranged from the practical to the luxurious to the truly odd. Beyond the everyday sewing machines, clothing, furniture, dishes, wagons, buggies, shoes, baby carriages and musical instruments, the Sears Catalog also sold tombstones, radium to treat gray hair, arsenic to whiten the complexion, Lysol "for feminine hygiene" and tapeworms as a diet aid. Catalog inventory steadily grew as people began writing to "Dear Mr. Sears," asking if he sold this or that. Usually the answer was "yes," although supposedly more than one person hoped to order a spouse through the Sears catalog, which presented freight difficulties.

Uterine supporter. *Northwestern University Archives*.

Sears Watch & Jewelry Department. *Northwestern University Archives*.

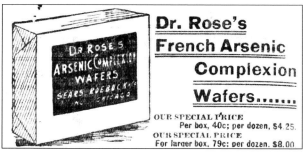

Left: Peruvian wine of coca. *Northwestern University Archives.*

Right, top: Tobacco cure. *Northwestern University Archives.*

Right, bottom: Arsenic, so good for the complexion. *Northwestern University Archives.*

After several years of back-and-forth, in which Sears sold the business to Roebuck and then bought it back, the first Chicago branch of Sears, Roebuck & Co. opened in 1893 on West Van Buren, just east of Halsted. That year's general merchandise catalog was 322 pages, and demand was so great that, three years later, the company moved to the Enterprise Building at the corners of Fulton, Des Plaines and Wayman Streets. For the next few years, Sears worked day and night writing copy and filling orders, while the company was continually modifying and expanding the office space.

But although Richard Sears was a promotional genius and a brilliant marketer, he wasn't a good manager. In fact, he was somewhat terrible. Without the space to store large amounts of goods, he often ran out of stock in those early days and had to delay or even cancel orders. This disorganization drove Alvah Roebuck nearly to the brink of madness. The final straw came in 1895, the day Richard Sears piled unfilled order slips in the yard and burned them. After this, Roebuck sold his share to Sears for $25,000 (over $700,000 in 2018).

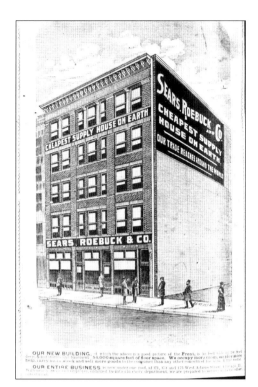

Right: The first Sears, Roebuck & Co. plant on Adams Street, just east of Halsted, 1893. *Northwestern University Archives.*

Below: Trains carried Sears catalog orders to every corner of the country. *Library of Congress.*

According to biographer Peter Ascoli, "Sears liked to experiment with ad campaigns and fliers, often selling products he did not have on hand. If the ad campaign was successful, he would have to obtain inventory in a huge hurry." One famous story tells of Richard Sears desperately contacting Newborg, Rosenberg & Co. for an immediate order of ten thousand men's suits. Surprised, Newborg tried to persuade Sears to start with a smaller order—perhaps one thousand suits—and wait to see if those sold before ordering more.

"You don't understand," Sears cried. "I've already sold them, and need to fill the orders I've got!"

In that case, Newborg advised, Sears should get the suits directly from their newly formed Chicago branch, Rosenwald & Co.

JULIUS ROSENWALD

The Greatest Philanthropist You've Never Heard Of

The name Rosenwald has never graced the cover of a Sears Catalog or store façade, but it deserves as much credit for the company's success as that of the founder himself. The only reason there is no Rosenwald University or Rosenwald Museum in Chicago is because Julius Rosenwald didn't like having his name on things. J.R., as he was known to his friends, made his fortune as a clothing manufacturer. He is best remembered as a philanthropist dedicated to advancing public education and racial equality. Rosenwald made several "magnificent gifts" to the University of Chicago, including a German library, a medical school, a maternity hospital and the Oriental Institute. He also founded the Museum of Science and Industry, built a large housing complex for African American workers in Chicago's Bronzeville neighborhood and regularly donated large sums to Hull House and Provident Hospital, the first African American owned and operated hospital in the United States.

In 1895, Rosenwald's brother-in-law, Aaron Nussbaum, persuaded him to jointly invest $50,000 in Sears, Roebuck & Co. The official version from the Sears Archives is that J.R. "brought a rational management philosophy to Richard Sears' well-tuned sales instincts."[8] This is a polite way of saying that Rosenwald brought order out of chaos. As president of Sears, Roebuck & Co. from 1908 to 1924 and chairman of the board for eight years after that, Rosenwald's managerial style reflected both his business acumen and his humanistic spirit. He developed a more efficient system for processing and sending orders, bought warehouses all over Chicago to ensure that Sears

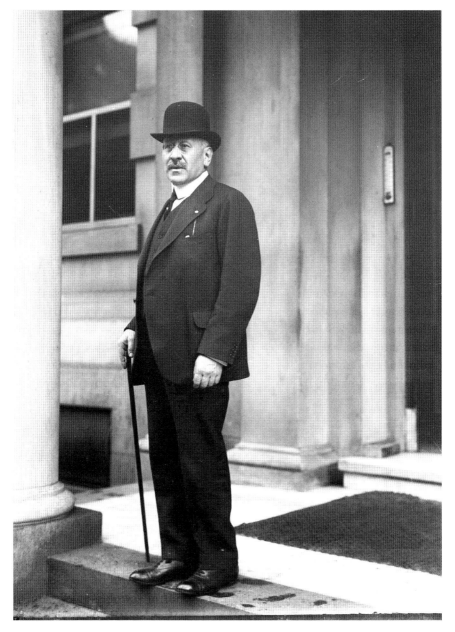

Julius Rosenwald, pictured here in 1917, was a pillar of the community. *Library of Congress.*

Left: Aaron Nussbaum, treasurer and general manager of Sears, Roebuck & Co. *Library of Congress*.

Right: Julius Rosenwald, vice-president of Sears, Roebuck & Co. *Library of Congress*.

always had a ready supply of merchandise on hand, built factories, and founded a savings bank for Sears employees that paid 5 percent interest. He also urged Sears to remove from the catalog all "snake oil" patent medicines, handguns, ammunition, gunpowder and electrically wired belts, which claimed to cure impotence.

One of the most significant contributions Rosenwald made to Sears was a program that allowed employees "to share in the profits of this business, and to encourage the habit of saving."[9] The program tripled profits within the first two years and offered incentives to employees who waited longer than ten years to withdraw the full amount. The only exception to this rule was that a female employee who was about to leave the company to get married could withdraw her full share without penalty.

Ninety-eight-year-old Bob Judd, who started as a control buyer at the Great Works and retired from Sears in 1980, recalls: "The best part was the feeling that Sears would take care of me while I worked there." It wasn't unusual for employees to earn more from profit-sharing than they did from their regular salaries. Frank F. Winters, Sears's national retail marketing manager from 1951 to 1972, liked to tell the story of a "young, illiterate

Let Sears help you make your last purchase ever! *Northwestern University Archives.*

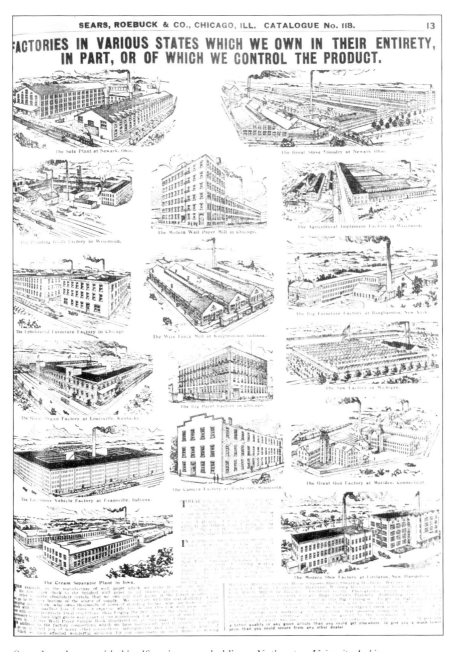

Sears has always prided itself on its many holdings. *Northwestern University Archives.*

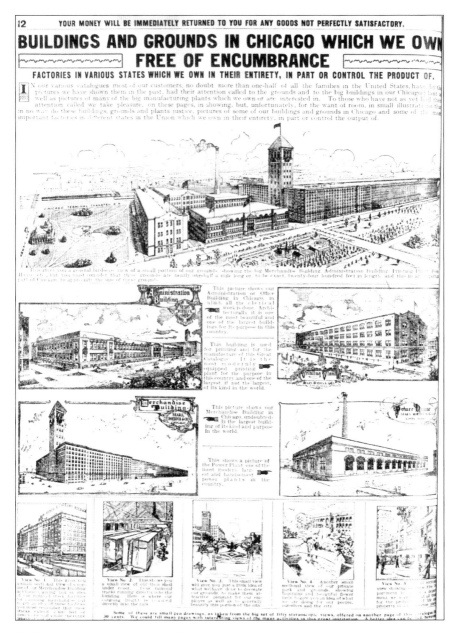

By 1916, Sears owned numerous office buildings, factories and warehouses all over Chicago. *Northwestern University Archives.*

Parcel post delivery, introduced in 1913, made it easy for Americans to order and receive goods through the mail. *Northwestern University Archives.*

porter" who signed up for profit-sharing at the time he joined the company… and then completely forgot about it. Sears sent a company man to track down the retired porter and present him with a check for the shared profits he'd earned, which totaled a whopping $250,000.

THE GREAT WORKS

U nder Rosenwald's leadership, Sears, Roebuck & Co. had outgrown even its Fulton Market location, which now included three separate buildings in addition to the massive Enterprise Building. But purchasing more retail space in the increasingly constricted Chicago Loop wasn't a good long-term strategy. Express shipping companies were already complaining that the constant stream of horse-drawn wagons in and out of the area

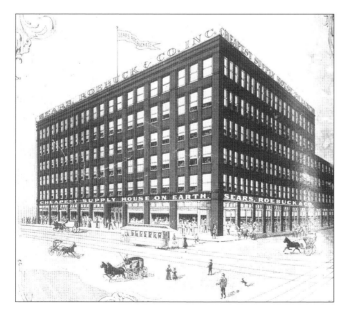

The Enterprise Building was much bigger than the Adams Street plant… but still not big enough. *Northwestern University Archives.*

By 1900, even five buildings weren't enough to contain Sears's expanding business. *Northwestern University Archives.*

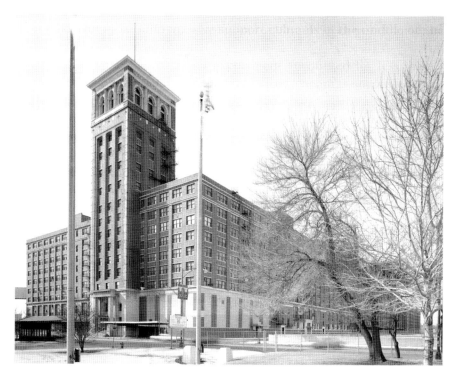

The Merchandise Building, 924 South Homan Avenue, Chicago. *Library of Congress.*

made Sears a risky customer, since traffic gridlock threatened the timely shipment of goods. Instead, Rosenwald bought forty-one acres of land along the Belt Line Railroad in the Lawndale neighborhood, just south of Garfield Park. Only then did he and Vice-President Arthur Loeb begin to make plans for a new headquarters complex.[10]

Louis J. Horowitz, the president of the Thompson-Starrett building company in New York, later recalled in his memoir that "Sears, Roebuck & Company rather suddenly had decided to build a new plant on the West Side of Chicago....Beyond the $4,000,000 estimate their architects had given them, Mr. Rosenwald and Mr. Loeb had no information at all; no plans, no specifications. However, they had their site and they wanted the plan; indeed, they wanted it as of yesterday from the time of starting."[11]

Horowitz traveled to Chicago to meet with Rosenwald and Loeb, determined to prove his company was as good as he said it was: instead of its regular fee of $250,000, he offered to put up the $4 million building complex for a single dollar. Once the job was completed, Rosenwald himself could decide whether Thompson-Starrett had earned the additional $249,999.

In the end, they settled on an upfront fee of $40,000, with no contractual guarantee of further payment unless Sears was satisfied. His boss was privately skeptical that the firm would ever see a penny more, but Horowitz trusted Rosenwald to keep his end of the bargain.

Construction began on January 24, 1905. It took seven thousand workers, fifteen million feet of lumber and twenty-three million bricks to build the complex, nicknamed the Great Works. Each day, sixty freight cars loaded with brick, lumber, sand, cement, stone and other materials arrived and were immediately unloaded and put to work building Sears's "city within a city."

The seven-thousand-horsepower Power House supplied the electricity for all escalators, conveyor belts, telephones, ventilation, lighting and more than ten miles of pneumatic tubing that ran throughout the Great Works. The Administration Building, not surprisingly, housed all executive and clerical offices, as well as Sears's vast mail room. In the Printing Building, three hundred typesetters worked in the largest private press room in the world, turning out thirty thousand catalogs a day. After Sears outsourced its catalog printing to Chicago-based printer R.R. Donnelley & Sons, this structure was renamed the Merchandise Development and Laboratory (MDL) Building (see page 22) and was the center of product testing until the 1970s.[12]

The fourteen-million-cubic-foot Merchandise Building housed no fewer than fifty-six departments, "all engineered to make order fulfillment relentlessly efficient, a precise science." Two separate conveyor systems ensured that "incoming never interrupts outgoing." A series of seven spiral chutes brought merchandise down from the higher floors in baskets, using centrifugal force to regulate the speed so that "even glass wares will go down without breaking." Items came down onto conveyor belts that ran around all four sides of the internal court, to be sorted by clerks and placed on another conveyor belt headed to whichever of the three shipping rooms—for mail, for express or for freight—was indicated on the routing ticket. There the items were placed in a basket marked by order number. The baskets were placed on long rows of shelves and then sent down a slide to a packer, who quickly determined the size box required, called out its number and was handed the appropriate container. Empty boxes were brought in overhead, via another system of conveyors. Smaller products were processed in the Merchandise Building, and bulkier items and prepackaged products such as groceries were handled in the annexes (see page 23).[13]

The U-shaped Merchandise Building stretched around two sets of railway switches—one for incoming freight and one for outgoing. At its

peak, this vast interlocking system of people and machinery could process as many as 105,000 orders in a single day, and all had to be shipped out within twenty-four hours of receipt. Theodore Thompson-Starrett was certain that "you could bundle the entire Pullman plant, including not only the factories but the workingmen's houses, the town market and the theatre, into the single Merchandise Building of Sears, Roebuck & Company and still not fill it."

The crowning glory of the complex, however, was the original "Sears tower." At fourteen stories, this red brick structure was the tallest in Chicago outside of downtown. In its basement was the nexus of the many pedestrian tunnels that connected the buildings; the upper floors contained offices and secretarial training facilities, while the top two floors stored water for the complex's state-of-the-art sprinkler system. The tower "soon became the most recognized structure associated with the Sears company brand. Images of the tower were prominently displayed in early Sears catalogs and in literature touting the company's modern new headquarters…[and] used to market Sears's 'Tower' line of office supplies and watches" (see page 28).

The Great Works had its own post office, hospital, in-house medical staff, a recreation room, a lending library, a gender-segregated cafeteria, five restaurants, a newspaper office, private bank, firehouse and, later, its own police force. As the decades progressed, Sears added tennis courts, a clubhouse and its own branch of the YMCA. Company baseball games and annual track and field competitions "encouraged after-work socialization to keep morale high among their employees." To "attract employees out of doors during the noon recess," there was a sunken garden complete with fountains, a one-hundred-foot shaded walkway and a lake filled with goldfish. Sears felt that "a change of environment and attractive surroundings send [employees] back to work again greatly refreshed and forgetful of the little annoyances of the morning."

In the same month the Great Works was completed, Theodore Starrett published an article in the *Architectural Record* entitled "Building a Great Mercantile Plant," which really deserves to be read in its entirety, but its opening paragraph gives you an idea of the almost-mythic status he bestows on building the largest mercantile plant in the world:

> *Have you ever read some stirring tale of heroic action, some story of a battle, for instance, and with bated breath and beating heart followed in your imagination a bloody charge like that of the Six Hundred of Balaklava—half a league, half a league, half a league onward, on through the valley*

of death? And have you ever sighed as you finished the story and thought of the good days and the brave days when money-getting had not become the modern fetish, and deeds of derring-do were not a memory or a fable? If you did, let me tell you, you were wrong. Those heroes still live.

After glorifying in poetic detail the record number of bricks laid in a single day (353,000), the "almost appalling" amount of lumber ordered and the construction details of each building, he ends on a sentimental note: "I have a photograph of the leading men on the work taken on the occasion of the raising of the last timber of the Merchandise Building….Some inglorious Milton has written on the picture:

> *'We raised the last post with many a shout,*
> *As the rain in torrents fell.*
> *And though our backs were soaking wet,*
> *Our breasts with pride did swell.'"*

On January 15, 1906, the Great Works was turned over to Sears. Within a week, over two hundred wagons had completed the move from the company's previous Fulton Market home. The entire process, from breaking ground to occupation, had taken just under a year. The cost of construction was $4,282,000, with the equipment bringing the final price tag to $5.6 million. Every thirty days, Thompson-Starrett had sent Sears a bill for labor and materials, which Sears promptly paid "out of the till." After the last invoice was settled, Louis Horowitz received a letter from Julius Rosenwald. For a moment, Horowitz worried; what if Bedford's skepticism proved to be right?

Inside the envelope was not one check, but two. There was also a note, in J.R.'s handwriting:

> *Because your company did what you said it would do, I enclose a check for $210,000.*
>
> *Because you accomplished something beyond our expectations, I enclose also an extra check for $50,000.*[11]

In true Sears fashion, the company wasn't about to let its status as home to the largest mercantile plant in the world go unnoticed or unappreciated. The promotion department touted its new headquarters with the same exuberance it used to sell its merchandise. The Great Works became a tourist attraction in its own right, appearing on postcards and in newspaper

advertisements that invited visitors to "Come and see us when you are in Chicago!" and boasted that the teenage girls who opened and processed the 180,000 letters received each day were "far above the average in intelligence!"

4

THE END OF THE BEGINNING

W ithin a few years of completing the Great Works, Sears faced another challenge: strain at the highest levels of its leadership.

> *Tensions between Sears and Rosenwald…came to a head in 1907 when the nation experienced a severe financial panic, and for the first time in its history, Sears, Roebuck & Co. failed to set a new sales record. Richard Sears wanted to increase advertising to offset the decline. Rosenwald, on the other hand, wanted to cut staff and other expenses and await the general upturn of the national economy. The conflict was put to a vote of top management. Rosenwald's conservative, cost-cutting approach won. As a result, the company's profit performance improved in 1908, even though sales declined as anticipated.*

Richard Sears's transition from president to chairman of the board was entirely symbolic; in the six years he held the position, he never attended a board meeting. The official story was that he was stepping down to care for his ailing wife, Anna, who ended up outliving him by thirty-two years. On September 28, 1914, "Dear Mr. Sears" died at the age of fifty. He is buried in the Sears family mausoleum at Chicago's Rosehill cemetery, where he lies among many of Chicago's most renowned captains of industry: Oscar Mayer, John G. Shedd, Cyrus McCormick, Marshall Field and his former partner Julius Rosenwald.

From now on, the Sears family—employees, customers and shareholders—was in Julius Rosenwald's hands.

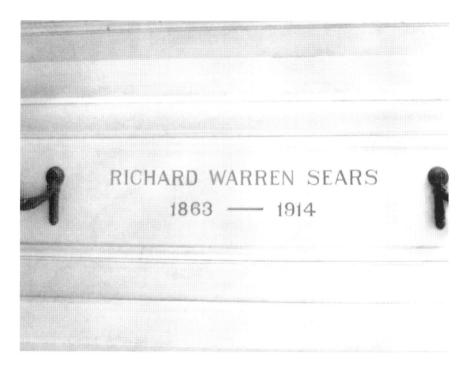

Above: Richard Sears's crypt in the Sears Memorial, Rosehill Cemetery, Chicago. *Author's collection*.

Left: Exterior view of the Sears family mausoleum, Rosehill Cemetery, Chicago. *Author's collection*.

Right: Marble and stained-glass interior of the Sears family mausoleum, Rosehill Cemetery, Chicago. *Author's collection.*

Below: Julius Rosenwald's grave, Rosehill Cemetery, Chicago. *Author's collection.*

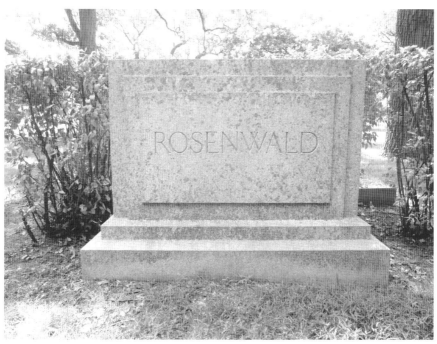

5

SEARS MODERN HOMES

The same year Richard Sears stepped down as president of the company, the catalog that bore his name began to sell the American Dream itself: homeownership. Sears, Roebuck & Co. already sold home furnishings, appliances and hardware. Why not the house itself? The company had offered a home-building materials catalog since 1895, but it wasn't until 1908 that page 594 carried a headline that started it all: "$100 set of building plans free. Let us be your architect without cost to you."[15]

Kit homes was an early twentieth-century innovation that made it easier for farmers and others of modest means to achieve the American Dream of homeownership. The Honor-Bilt homes Sears offered were affordable, but certainly not cheap.[16] Like everything else, it depended on what you wanted. At the low end of the scale, a basic three-room Sears Natoma cost $191 in 1908 ($4,880 today), while the ten-room Magnolia retailed for $5,849 in 1922 ($87,229 today). Once Sears began offering "already cut and fitted" homes in 1915, as well as financing, the industry took off.

Sears was able to offer quality building materials at wholesale prices, buying lumber mills, lumber yards, millwork plants (conveniently located near the railroad lines in Norwood, Ohio[17]), as well as an entire cypress forest in Florida.[18] On average, an enterprising home builder might save as much as 30 percent with a Sears kit home. Much of the savings, of course, came from doing the construction yourself. In home sales, as with catalog sales, Sears wasn't the first. Harris Brothers of Chicago had sold houses

since 1907; Montgomery Ward followed suit in 1909, partnering with kit home retailer Gordon Van Tine. But as usual, Sears quickly showed the competition how it was done. "Sears tried to make it as easy as possible," says architectural historian Rebecca Hunter. "You could write them and get a free catalog, and you'd go through the catalog and pick the house of your dreams." Once you sent in your one-dollar "good faith" deposit, your detailed set of building plans would be in the next post.

"The customer must be satisfied for a lifetime," stated a 1918 Sears company history, "for every house we sell is a standing advertisement for Sears, Roebuck and Company."[19] Sears paid tribute to its Chicago roots in an early advertising campaign for its kit homes. After the Great Fire of 1871, the city had adopted "I Will" as its motto during rebuilding. A *Chicago Tribune* contest invited readers to draw the new Spirit of Chicago. The winning entry depicted a female figure in classical garb wearing a crown topped with a phoenix, which Sears later adapted as the "I Will Girl" in its kit home advertisements.

Sears offered at least 370 different models of Honor-Bilt homes between 1908 and 1940, manufacturing and selling between 65,000 and 75,000 kit homes in the United States and Canada. The raw materials were assembled and delivered in boxcars: lumber, cabinetry, laths, mortar, roof shingles, nails, drywall, siding, varnish, gutters, columns—everything you would need to make the home of your dreams a reality.

Well, not quite everything. Bricks and masonry were not included; Sears encouraged customers to buy these locally in order to save on freight charges. Plumbing, heating and electrical equipment were also sold separately. In the first half of the twentieth century, rural customers might consider any or all of these needless luxuries. Even a hardy little Cape Cod in the Chicago suburbs reportedly used only isinglass space heaters until the beginning of the twenty-first century. Entire kitchens and bathrooms were sometimes sold as add-ons to smaller home models that did not include them. And of course, the Sears general merchandise catalog offered a wide selection of sinks, pumps, iceboxes and stoves that burned wood or coal, as well as outhouses to suit every family's needs. Knowing that homeowners make the best customers, Sears offered personalized service, allowing homeowners an endless array of custom options to make their homes feel homier. And, of course, the general merchandise catalog sold doors, windows, millwork and more, besides the furnishings and decorative touches. According to Hunter, "it's been said that Sears went into [the kit home] business in the hopes of selling more building materials."

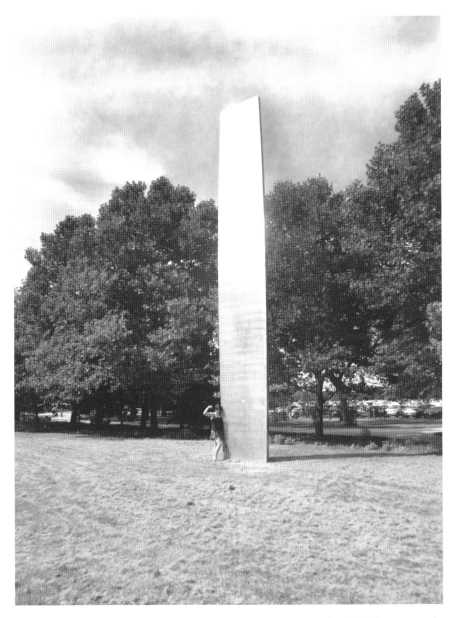

I Will. Ellsworth Kelly's minimalist sculpture on Cannon Drive in Lincoln Park was named for the motto adopted by Chicagoans after the Great Fire of 1871. "The hollow stainless steel column, rising from the ground at the fire's northernmost end, is dedicated to the determination of Chicagoans to overcome the destruction of the fire and rebuild the city." Author included for scale. *Author's collection.*

Left: Sears Modern Homes catalog, 1909. *Northwestern University Archives*.

Below: Builder's hardware and materials. *Northwestern University Archives*.

O. G. FIVE PANEL DOORS.

No. 14360. First Quality.

Size, ft. in. ft. in.			Thickness. in.	Price.
2	6x6	6	1⅜	$1 75
2	6x6	8	1⅜	1 78
2	8x6	8	1⅜	1 85
2	10x6	10	1⅜	2 10
2	6x6	6	1¾	3 12
2	8x6	8	1¾	3 17
2	10x6	10	1¾	3 58
2	6x7		1¾	3 44
3	x7		1¾	3 67
3	x7	6	1¾	4.15

O. G. SASH DOORS.

No. 14361. One light, double strength, plain glass; raised panel; thickness of door, 1⅜ inches; square corners not moulded, otherwise as shown in cut.

Size, ft. in. ft. in.			Price. each. unglazed.	Price. each. glazed.
2	6x6	6	$1 77	$3.12
2	8x6	8	1 90	3.44
2	10x6	10	2 10	3.94
2	6x7		2 20	3.80
3	x7		2 41	4 39
3	x7	6	2 70	5.20

We can furnish any size door. Prices quoted upon application.

Panel and sash doors. *Northwestern University Archives.*

A simple kit home might include twelve thousand pieces, with more elaborate homes typically between thirty and seventy thousand pieces. Every house came with a seventy-five-page instruction book, bound in leather, with the homeowner's name embossed in gold on the cover. Easy, right? Now all you had to do was build it.

The Sears Modern Homes Catalog asserted that "a man of average abilities" could build the entire home from foundation to rooftop in ninety days. Obviously, this was on the optimistic side; most people needed between three and four months.[20] Kit home researcher Lara Solonickne recounts a case of one homeowner who, after working six days a week at his regular job, took the train from Chicago's Austin neighborhood to suburban Villa Park each Sunday to work on building his Sears home. Amazingly, he finished it in two years.

It wasn't long before enterprising contractors started buying up lots, building a Sears kit home on each and selling them at a profit. Eventually, Sears began asking customers to return the blueprints once their home was completed. Today, the only reason any Sears Honor-Bilt home blueprints exist at all is thanks to a few homeowners who fortunately didn't listen. These blueprints help kit home historians authenticate other homes and verify that Sears's architectural talent pool included names familiar to many Chicago bungalow and Prairie School enthusiasts. These include Charles E. White and John S. van Bergen, both of whom had also worked in Frank Lloyd Wright's studio in Oak Park. Another uncredited contributor was George C. Nimmons, "an early twentieth-century expert in industrial architectural design and a master in combining the Chicago School principle of a clearly- and rationally-expressed structure with Classical- and Prairie-style ornament."[21] The architectural firm of Nimmons, Carr & Wright had also designed the Great Works and Julius Rosenwald's South Side mansion in the Kenwood neighborhood.

According to Lara Solonickne, many Chicago-area homeowners hired contractors to dig and pour the foundation, but an astonishing 70 percent built their Sears homes themselves. There was absolutely nothing

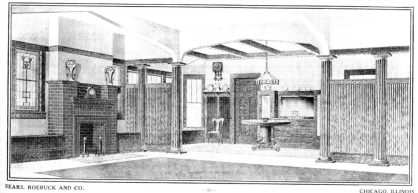

Typical bungalow interior. *Photo credit: Antique Home (www.antiquehome.org).*

prefabricated about Sears houses; save for cutting the lumber, you were on your own. Entire families, young and old, worked together to make the family home a reality. Every piece of lumber was stamped with an alphanumeric code indicating where it was to be placed. "Invariably," Hunter says, "the children's jobs were to sort the boards by number." These serial numbers are now used to distinguish authentic Sears kit homes from their many impostors. Many Sears kit homes still survive around Chicagoland, including in Glen Ellyn, Lombard, Downers Grove, Libertyville, Des Plaines, Woodstock, Itasca, Villa Park, Elgin, Aurora and Waukegan.

Sears also figured out that people were more likely to buy homes when they were advertised not by number, but by name. The advertising department worked overtime to brand each home with a creative, picturesque name that conveyed its character. Many of these names were inspired by Chicago neighborhoods and suburbs: Avondale (1911–22), Aurora (1918), Barrington (1928), Berwyn (1929–33), Dundee (1921–29), Elmhurst (1930–32), Flossmoor (1912–20), Galewood (1930–33), Glen View (1933, 1936–37), Homewood (1915–28), Maywood (1928), Oak Park (1926), Park Ridge (1930), Riverside (1934), Wayne (1925–31) and Wheaton (1930–33).

Hunter claims there are three requirements to find a lot of mail-order houses in any given town: good railroad access, population growth in the 1920s and, of course, "it kind of helps if you're near Chicago, Illinois, which was Sears headquarters."[22] Solonickne offers a fourth: some neighborhoods commit more teardowns than others, and you're obviously more likely to find an intact Sears Honor-Bilt home in an intact location.

The suburb of Elgin meets all of those, boasting the greatest number of Sears kit homes in the Chicago area. "In Elgin we know a lot about our Sears homes," says Hunter proudly. The current count stands at 213, many with original woodwork and fixtures, including inset radio cabinets. Elgin homeowner Susan Riddle-Mojica marvels, "There's something fascinating about the thought [that] this whole house came on a railroad car, and was unpacked in boxes, and put together like a huge puzzle."

With $12 million in sales, 1929 was a record year for Sears kit home sales—the last, as it turned out. The Depression didn't hit the Sears housing market immediately, but when it did, it hit hard. The Modern Homes department suffered "terrific losses" in 1931 and 1932, finding itself stuck with the titles to 396 properties through foreclosures or quitclaims. The Modern Homes department temporarily closed in 1933 and 1934 to recover from the disastrous effects of the Great Depression, liquidating $11 million

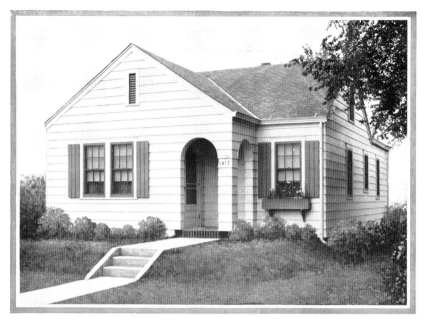

The BERWYN Five Rooms and Bath

No. 3274—Already Cut and Fitted
Monthly Payments as Low as $30 to $40

IN DESIGNING small homes, the main thing to keep in mind is to obtain an attractive appearance on the exterior and a convenient arrangement of the interior and yet keep the construction cost as low as possible. In presenting this five-room design, we have observed the above requirements, resulting in a happy combination of these desirable features. The exterior looks equally attractive when finished with bevel siding or wide stained shingles. Under the front gable, a small entrance porch is designed, which gives the front door the necessary protection. The left side of the plan contains living room, dining room, kitchen, cellar stairs and platform for refrigerator. Two bedrooms, bath and closets make up the balance of this compact plan.

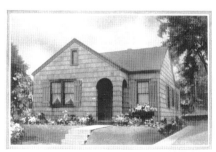

LOOKS *Equally Attractive With Gray Stained Shingles*

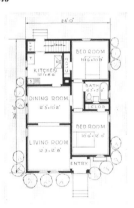

FLOOR PLAN
No. 3274—Honor Bilt Home can be built on a 30-ft. lot. For complete delivered price, fill out Information Blank enclosed.

HOME CONSTRUCTION DIVISION *Page 21*

The Berwyn—five rooms and a bath. *Photo credit: Antique Home (www.antiquehome.org).*

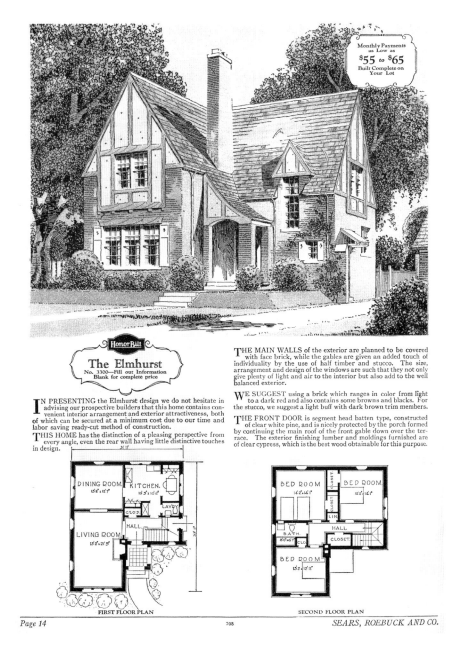

Monthly Payments
as Low as
$55 to $65
Built Complete on
Your Lot

Honor Bilt

The Elmhurst
No. 3300—Fill out Information
Blank for complete price

IN PRESENTING the Elmhurst design we do not hesitate in advising our prospective builders that this home contains convenient interior arrangement and exterior attractiveness, both of which can be secured at a minimum cost due to our time and labor saving ready-cut method of construction.

THIS HOME has the distinction of a pleasing perspective from every angle, even the rear wall having little distinctive touches in design.

THE MAIN WALLS of the exterior are planned to be covered with face brick, while the gables are given an added touch of individuality by the use of half timber and stucco. The size, arrangement and design of the windows are such that they not only give plenty of light and air to the interior but also add to the well balanced exterior.

WE SUGGEST using a brick which ranges in color from light to a dark red and also contains some browns and blacks. For the stucco, we suggest a light buff with dark brown trim members.

THE FRONT DOOR is segment head batten type, constructed of clear white pine, and is nicely protected by the porch formed by continuing the main roof of the front gable down over the terrace. The exterior finishing lumber and moldings furnished are of clear cypress, which is the best wood obtainable for this purpose.

FIRST FLOOR PLAN

SECOND FLOOR PLAN

The Elmhurst. *Photo credit: Antique Home (www.antiquehome.org).*

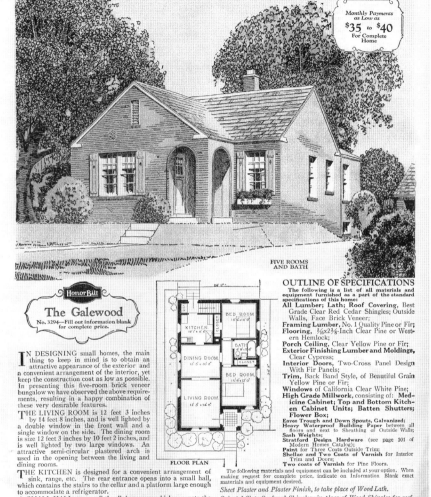

Monthly Payments
as Low as
$35 to $40
For Complete
Home

FIVE ROOMS
AND BATH

HonorBilt

The Galewood

No. 3294—Fill out information blank
for complete price.

IN DESIGNING small homes, the main thing to keep in mind is to obtain an attractive appearance of the exterior and a convenient arrangement of the interior, yet keep the construction cost as low as possible. In presenting this five-room brick veneer bungalow we have observed the above requirements, resulting in a happy combination of these very desirable features.

THE LIVING ROOM is 12 feet 3 inches by 14 feet 8 inches, and is well lighted by a double window in the front wall and a single window on the side. The dining room is size 12 feet 3 inches by 10 feet 2 inches, and is well lighted by two large windows. An attractive semi-circular plastered arch is used in the opening between the living and dining rooms.

THE KITCHEN is designed for a convenient arrangement of sink, range, etc. The rear entrance opens into a small hall, which contains the stairs to the cellar and a platform large enough to accommodate a refrigerator.

A SMALL HALL opens off the dining room, which connects the front and rear bedrooms and bath. Each bedroom is well lighted with two windows which are arranged to give cross ventilation.

THE BASEMENT is designed to be excavated under the entire house and contains space for heating plant, laundry and storage. Height of ceilings: First floor, 8 feet 6 inches; basement, 7 feet from cellar floor to under side of joists.

Complete Plans, Specifications and Instructions for erection. We also include all face brick for exterior walls, chimney and exposed part of foundation walls.

We guarantee enough material to build this home, but we do not furnish cement, plaster or common brick required.

FLOOR PLAN

OUTLINE OF SPECIFICATIONS

The following is a list of all materials and equipment furnished as a part of the standard specifications of this home:

All Lumber; Lath; Roof Covering, Best Grade Clear Red Cedar Shingles; Outside Walls, Face Brick Veneer;

Framing Lumber, No. 1 Quality Pine or Fir;

Flooring, 3⁄8x2¾-Inch Clear Pine or Western Hemlock;

Porch Ceiling, Clear Yellow Pine or Fir;

Exterior Finishing Lumber and Moldings, Clear Cypress;

Interior Doors, Two-Cross Panel Design With Fir Panels;

Trim, Back Band Style, of Beautiful Grain Yellow Pine or Fir;

Windows of California Clear White Pine;

High Grade Millwork, consisting of: **Medicine Cabinet; Top and Bottom Kitchen Cabinet Units; Batten Shutters; Flower Box;**

Eaves Trough and Down Spouts, Galvanized; Heavy Waterproof Building Paper between all floors and next to Sheathing of Outside Walls; Sash Weights;

Stratford Design Hardware (see page 101 of Modern Homes Catalog);

Paint for Three Coats Outside Trim;

Shellac and Two Coats of Varnish for Interior Trim and Doors;

Two coats of Varnish for Pine Floors.

The following materials and equipment can be included at your option. When making request for complete price, indicate on Information Blank exact materials and equipment desired.

Sheet Plaster and Plaster Finish, to take place of Wood Lath.

Oriental Slate Surfaced Shingles, in place of Wood Shingles for roof, or 4-In-1 Style Oriental Asphalt Slate Surfaced Strip Shingles, 12½ inches wide, guaranteed for seventeen years.

Storm Doors and Windows and galvanized wire Screen Doors and Windows.

Oak Trim, Doors and Floors in Living Room and Dining Room.

Shades.

Maple Floors in Kitchen and Bathroom, instead of Pine.

Refer to pages 104 to 112, inclusive, of Modern Homes Catalog for style of the following equipment desired:

Complete Heating Plant, either Warm Air, Steam or Hot Water.
Plumbing, Electric Wiring and Fixtures.

The Galewood—five rooms and a bath. *Photo credit: Antique Home (www.antiquehome.org).*

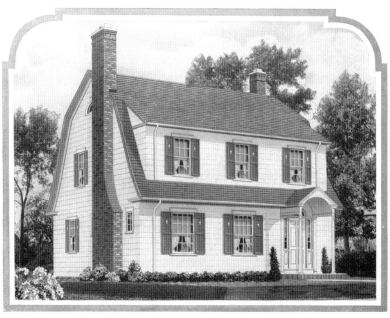

The OAK PARK Eight Rooms and Bath

No. 3288 Already Cut and Fitted
Monthly Payments as Low as $50 to $65

THERE IS A FASCINATING charm about this Dutch colonial home with its attractive colonial entrance. The front door is a six-panel design built of clear white pine. Glazed sidelights and fan shaped transom admit light to the front hall. The exterior walls are covered with 10-inch clear cypress siding, which when painted white or ivory form a good contrast with dark shutters and blended color roof.

FIRST FLOOR. A good size hall with a semi-open stairway to the second floor forms the entrance. The stair rail, treads and newels are of birch. The doorway to the kitchen passageway has a large plate mirror. The living room is 20 ft. 11 in. wide by 13 ft. 5 in. deep and the Dining Room is 14 ft. 5 in. by 12 ft. 11 in. with four sliding windows.

The floors of the dining room, living room and hall are of clear oak. Breakfast alcove and kitchen floors are covered with linoleum. The Kitchen contains two large cabinets and a broom closet. The back stairs form a space underneath the main stairs for the refrigerator.

SECOND FLOOR. By careful planning we have obtained four large well balanced bedrooms. The bedroom in the front at the right is 17 ft. 5 in. wide by 9 ft. 9 in. deep. Each bedroom contains large closets.

Fill out Information Blank for complete delivered price, photographic architectural elevations, floor plans and outline of specifications.

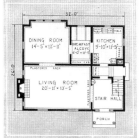

FIRST FLOOR PLAN

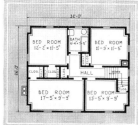

SECOND FLOOR PLAN

HOME CONSTRUCTION DIVISION

Page 33

The Oak Park. *Photo credit: Antique Home (www.antiquehome.org).*

60

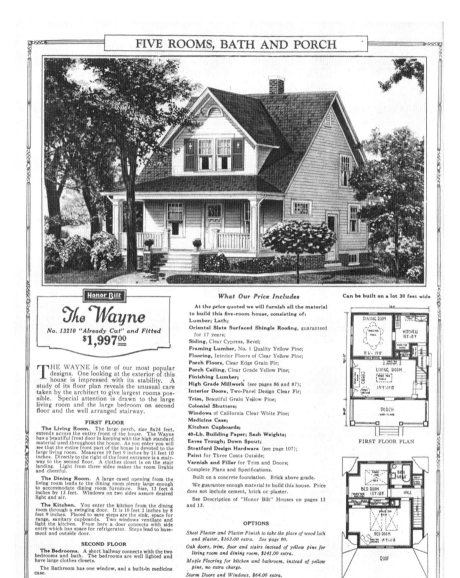

The Wayne. *Photo credit: Antique Home (www.antiquehome.org).*

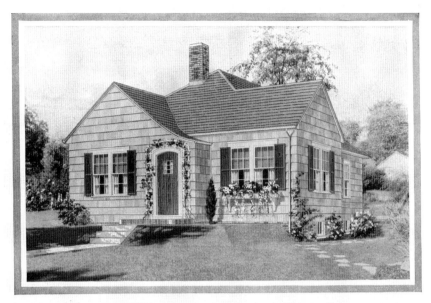

The WHEATON Five Rooms and Bath
No. 3312—Already Cut and Fitted
Monthly Payments as Low as $35 to $45

INTERESTING roof lines are the order of the day from sky-scrapers to cozy bungalows like the WHEATON, the interior arrangement of which is as well planned as the exterior. Opening off the center hall are a model kitchen, a bath with clothes chute and medicine case, a linen closet and four comfortable corner rooms with cross ventilation. Front and back entrances are protected by vestibules and the amount of closet space is remarkable.

The house is 30 ft. by 37 ft., not including the kitchen porch, and can be built on a 40 foot lot. For outside walls we suggest our 24-inch Clear Royal Shingles stained gray and laid with 10-inch face. For contrast, paint the trim ivory and use dark brown for front door and Colonial shutters.

FLOOR PLAN: Through a vestibule 5 feet wide, you enter a living room 15 ft. 5 in. by 12 ft. 4 in. with plastered arches to hall and dining room. In three of the rooms windows are arranged in pairs for pleasant effect and inexpensive curtaining. The living room contains two such pairs of windows.

There are big advantages in a centrally located kitchen with side entrance. It saves many steps and gives greater quiet and privacy to the bedrooms. This kitchen contains built-in cabinets and storage unit, folding ironing board, sink near windows, and space for refrigerator in the vestibule. There is a 6-foot closet for each of the two large bedrooms.

Fill out Information Blank for complete delivered price together with copies of the original architectural elevations and floor plans; also outline of specifications.

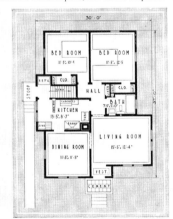

FLOOR PLAN

The Wheaton. *Photo credit: Antique Home (www.antiquehome.org).*

in mortgages ($192 million today) and even hiring a full-time employee to resell or rent reclaimed homes.

The myth that Sears never foreclosed on a mortgage and instead let hapless owners keep their homes is just that: a myth. Business was business, but Sears quickly learned that evicting customers was not good for public relations. "We don't want to sell a home and lose a friend," said Frank W. Kushel, general manager of the Modern Homes department, in a 1929 catalog blurb. Nevertheless, Sears lost 1,081 "friends" and families, who refused to shop at Sears forever afterward.[23] Happier stories about Sears stalling foreclosure to allow homeowners to catch up on payments probably date from after 1935, when the Sears Modern Homes department realized that foreclosure and eviction only got them stuck with more houses and bad publicity.

Alas, there's no reliable way to count the Sears kit homes that have been lost. Today, only a handful of kit home researchers dedicate themselves to finding, identifying, documenting and preserving this important piece of the history of Sears and of America. As historian Rosemary Thornton says, "They speak to a time in American history that is gone."

SEARS TAKES TO THE AIRWAVES

Every Chicagoan has listened to the WLS radio station. We heard Dick Biondi play the first Beatles record on U.S. radio in the 1960s, laughed along with Larry Lujack on our way to work in the 1980s and still tune in today to hear classic rock hits and talk radio. But how many can tell you what the station's call letters stand for?

The Sears Agricultural Foundation might have answered that with another question: why buy time on other radio stations when you could have your own?

American farmers were hit hard by the post–Great War recession, which meant they weren't buying from the Sears Catalog…or anywhere else. In 1921, Julius Rosenwald had to step in with $21 million of his personal fortune to save Sears, Roebuck & Co. from financial insolvency. Three years later, he established the Sears Agricultural Foundation, "designed to provide farmers with information, and aid them to do what they lacked the expertise to do themselves."[24] The foundation, in turn, determined that the best way for Sears to communicate with its far-flung customer base on farms and in cities was the new medium of the age: radio.

And so the World's Largest Store debuted its new station, WLS, on Saturday, April 12, 1924. Broadcasting from the original Sears tower, it featured weather and crop reports, market information, Sears advertisements, entertainment shows and what station manager Edgar Bill called "highbrow music."

The Hotel Sherman (now the site of the James R. Thompson Center), broadcasting headquarters for WLS. *Library of Congress.*

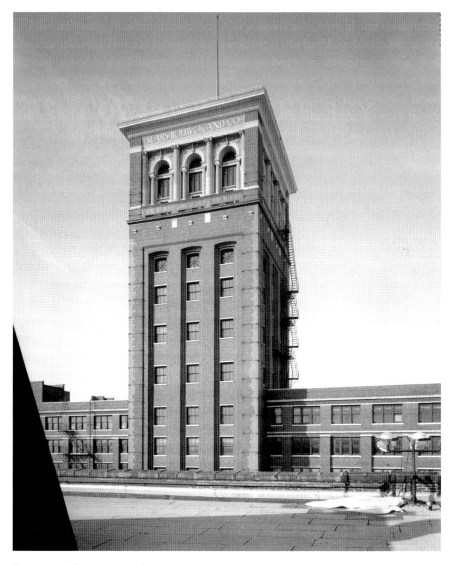

The original fourteen-story Sears tower. *Library of Congress*.

The following Saturday night, Bill decided to change things up and "get on some of the old-time music." It took less than an hour for Sears Roebuck executives, "aghast by this disgraceful low-brow music being broadcast," to contact Bill with their objections. In response, he showed them the twenty-five telegrams that had already arrived from delighted listeners who wanted more. After that, Sears's *National Barn Dance* became a regular staple on

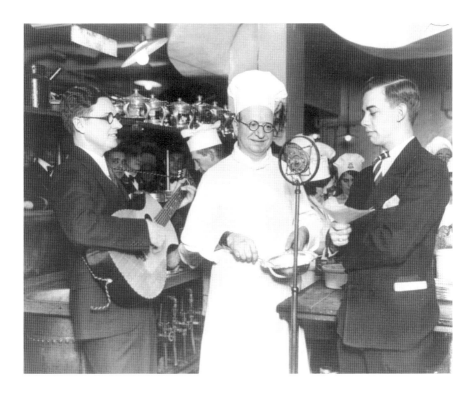

Above: Chef Tom Magliano broadcasting from the kitchen of the Sherman Hotel in 1929, with Bradley Kincaid (*left*) and Bob Boulton (*right*). *Library of Congress.*

Left: Main entrance of the Merchandise Building, at the base of the tower. *Library of Congress.*

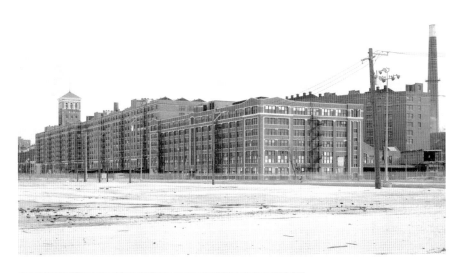

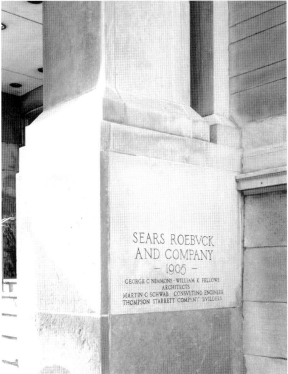

Above: Merchandise Building, view to southeast. *Library of Congress*.

Left: Northeast cornerstone of the Merchandise Building. *Library of Congress*.

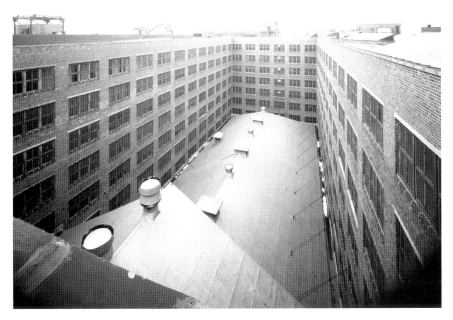

The massive shipping courtyard and roof of the train shed. *Library of Congress.*

Saturday nights and helped launch the careers of radio stars such as Charles Correll and Freeman Gosden (white actors who performed as Amos 'n' Andy) and Jim and Marian Jordan (better known as Fibber McGee and Molly).

Soon the WLS studio moved to the sixth floor of the Hotel Sherman, where, "in addition to its regular programming, it advertised special company activities and engaged in a variety of humanitarian projects, including fund raising for disaster relief following floods and tornadoes, appeals for toys for needy children at Christmas, and other public service functions."[25] Wheat growers in Kansas wrote to Sears headquarters in Chicago to learn how to organize a co-op, and farm boys' and girls' clubs could receive $1,000 to pay full-time staff. Even after Sears sold WLS to *Prairie Farmer* magazine in 1928, *National Barn Dance* remained on the airwaves for another forty years.

7

THE RETAIL REVOLUTION

W e do comparatively very little business in cities," Richard W. Sears had written in 1906, "and we assume the cities are not at all our field. Maybe they are not—but I think it is our duty to prove they are not."

The executive who made it his duty to prove that retail was indeed in Sears's field was Robert E. Wood. A retired brigadier general and religious conservative, Wood was very much the sort to disapprove of WLS's lowbrow hijinks. Yet Wood was a visionary with an almost prescient understanding of retail. He had been in charge of American supply lines during World War I, and he knew how to get large amounts of goods into the hands of customers across the United States. Before coming on board at Sears, Wood had a (very) brief stint as vice-president in charge of merchandising at Montgomery Ward, though he clashed with Ward's president, Sewell Avery, to such an extent that, even today, it's not clear whether Wood resigned or Avery fired him. What *is* certain is that, almost immediately, Julius Rosenwald hired Wood as vice-president in charge of Sears factories and retail stores in 1924.

There was just one minor problem: Sears had no retail stores. Yet.

Wood studied *The Statistical Abstract of the United States* and knew that America's demographics were shifting in a way that presented new opportunities for business. Chicago's population had grown from 1.1 million to 2.7 million[26] since Richard Sears had arrived in Chicago thirty-seven years earlier. Other cities were experiencing comparable population

The Administration Building in 2013. *Photo credit: Stephanie Barto.*

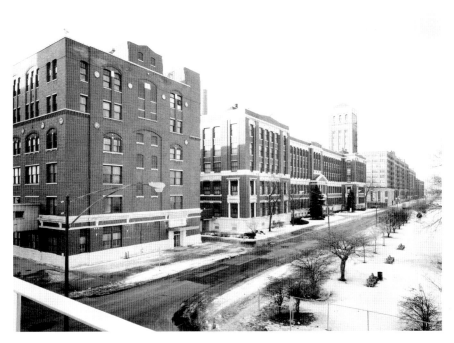

Printing and Advertising Building, Administration Building, Merchandise Building and garden. *Library of Congress.*

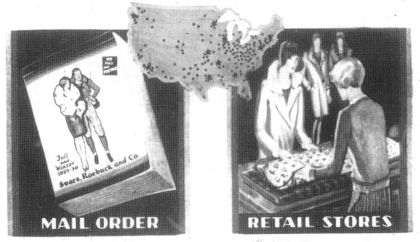

NATION-WIDE SERVICE

MAIL ORDER **RETAIL STORES**

The WORLD'S LARGEST STORE

"Nation-Wide Service." *Northwestern University Archives.*

explosions; for the first time in American history, urban populations outnumbered rural ones. Paved roads and cars meant that people could live in the suburbs and work in the city, or vice versa.

Sears's competition was also growing: other, smaller retailers had opened approximately 126,000 retail stores between 1914 and 1919, a 600 percent increase.[27] City folk didn't order from catalogs, Wood knew; they wanted the goods there in front of them to choose from, as they were already doing at Montgomery Ward and Carson Pirie Scott. Sears, Roebuck & Co. had to jump on this trend in order to stay competitive. Other Sears executives flatly refused to enter retail,[28] but Rosenwald was intrigued. He saw the retail store not only as reaffirming the bond of trust between seller and consumer (which, after all, is based on honesty) but also as a way of "humanizing the relationship between the firm and its employees".[29]

In February 1925, less than three months after his hire, Wood oversaw the opening of a 45,000-square-foot retail store in the Great Works complex on Homan Avenue. The store also offered an optical shop and a soda fountain, among other amenities, and was an immediate success.

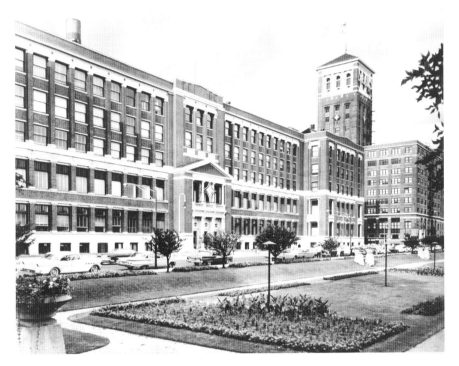

The Administration Building. *Northwestern University Archives.*

Over the next fifteen years, Wood personally directed the opening of six more stores located in the city itself.

The year 1928 brought two big changes for Sears and the city: the first independent Sears retail store opened at Sixty-Second Street and Western Avenue, and General Wood replaced Julius Rosenwald as company president. Like Richard Sears before him, Rosenwald now became chairman of the board, taking this duty more seriously than his predecessor had. On November 2, two more Sears stores opened, one on the North Side at 1802 Lawrence Avenue, the other on the South Side at 1334 East Seventy-Ninth Street. Both buildings were two stories, with lots of windows for light and ventilation. Both were built with the signature tower featured on all Sears stores and Catalog Merchandise Distribution Centers. Inside, the layout was simple: goods were displayed on tables not terribly different from a general store counter. Money and receipts were sent from the sales floor to the office via pneumatic tubes. A combined 120,000 people visited the stores during the first twelve

hours, navigating around massive support columns in the middle of the sprawling floor space.

In its first year, Sears's retail experiment accounted for less than 5 percent of sales. By 1931, Sears retail store earnings surpassed mail order for the first time, accounting for just over half (53.4 percent) of $180 million in total sales. It was working; Sears had built it, and people were coming. The following March, Sears opened its flagship department store on State Street, in the heart of downtown. The eight-floor structure, known as the Second Leitner Building, has occupied the entire block between Van Buren and Congress since 1891. It required 750 workers and over $1 million to transform this building into the fourth freestanding Sears store in Chicago. It featured a model hunting lodge in the sporting goods department, a candy shop, a soda fountain, lunch counters, a shoe repair shop, a pet shop, dentists, chiropodists, a playground and even a first-aid station.

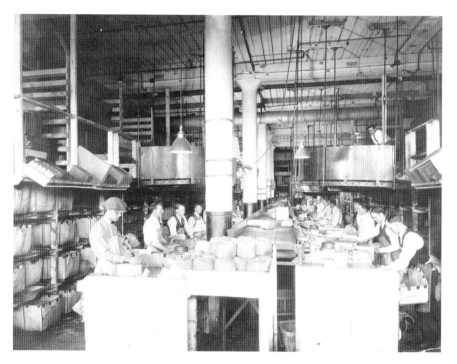

Tens of thousands of orders poured in every day, and each had to be processed within twenty-four hours. *Library of Congress.*

The Sears at Sixty-Second Street and Western Avenue. *Photo credit: Walter Kadlubowski.*

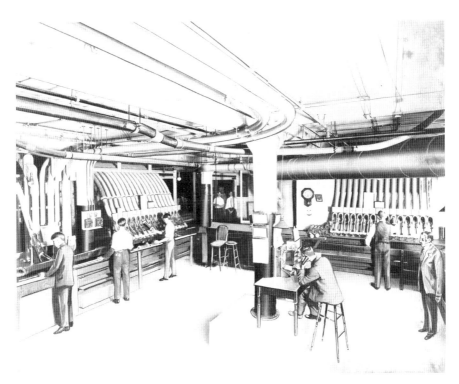

Pneumatic tube station in the Merchandise Building, 1918. *Library of Congress.*

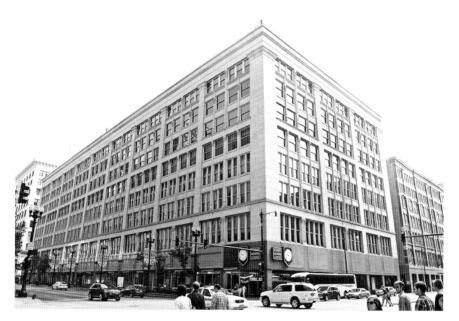

The flagship Sears store on State Street. *Photo credit: Walter Kadlubowski.*

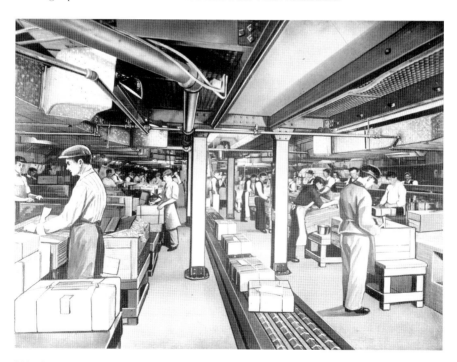

Shipping court of the Merchandise Building, circa 1918. *Library of Congress.*

When the State Street Sears opened, more than fifteen thousand people passed under its seventy-two-foot electric sign that first day, including one thousand job seekers. This was more than simply the opening of a store; it was hailed as a significant advance in the relationship between Sears and the city of Chicago. Sears chairman Lessing Rosenwald regarded "the opening of our new store on the world's greatest thoroughfare as one of the high spots of our company's history." Illinois governor Louis Emmerson sent a telegram of congratulations: "I cannot help but feel that this opening will mean a great deal for your organization as well as for your city."

SEARS AND THE CENTURY OF PROGRESS

The year 1933 was a hard one for Sears, and for much of the country. But for a few weeks at least, Americans could forget about the Depression and their troubles by visiting the "Century of Progress" World's Fair in Chicago. Oil tycoon Rufus C. Dawes and his brother, Charles G. Dawes, had persuaded local business leaders, including Julius Rosenwald, to secure $12 million in gold notes required to underwrite the initial costs of the fair, which ultimately reached more than $100 million.[30] Rosenwald's investment reflected Sears, Roebuck & Co.'s commitment to building community and industry in the midst of the Depression. And, of course, Sears always knew a good marketing opportunity when it saw one:

> *When it began to appear that merchandising would have no champion at the big progress show, Sears took up the challenge and appropriated a large sum of money to handle the job of flying the banner of distribution as one of the genuinely important sciences developed during the last century....In the Sears building are organized the services which a careful study indicated would be most important to fair visitors. The company provided free checking facilities, spacious and elaborate rest rooms and lounging rooms, a beautiful restaurant, a complete general information message exchange and travel department, a telegraph desk and batteries of telephones.*[31]

Sears lost no time capitalizing on its World's Fair connections, offering commemorative products and announcing its National Quilt Contest—the

Top, left: Sears capitalized on the World's Fair in its spring 1933 catalog. *Northwestern University Archives.*

Top, right: Sears offered commemorative 1933 World's Fair models of its Silvertone radios. *Northwestern University Archives.*

Bottom: First Lady Eleanor Roosevelt admires the grand-prize winner from Sears's National Quilt Exposition, while Sears executive E.J. Condon and L.T. Conway look on. *Library of Congress.*

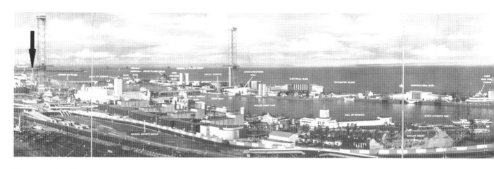

Panoramic picture of the 1933 World's Fair in Chicago. The Sears Building (with tower) is marked at the far left. *Author's collection*.

largest ever held—in the 1933 general merchandise catalog. The grand prize was $1,000, with additional prizes totaling $6,500. Sears received twenty-five thousand entries and selected the three best quilts from each region to be judged at the Chicago World's Fair. Approximately five million people visited the quilt exhibition in the Sears Building. Sears executives later presented the winning quilt, made by Margaret Rogers Caden of Lexington, Kentucky, to First Lady Eleanor Roosevelt.

Inspired by the art deco lines of the Sears Building at the World's Fair, Sears announced that its fifth freestanding Chicago store would be built in Englewood in the same style. It would be the company's first windowless department store—the first such store anywhere, as a matter of fact. From 1934 onward, all Sears stores followed this style. It was an ideal way to tie the company's public face with its already established icon of the Great Works headquarters on Homan Avenue.

In this same year, 1933, Alvah Roebuck returned to the company that bore his name—this time as a job applicant. He hadn't done too badly for himself since his buyout, even inventing the Woodstock typewriter. But like millions of Americans, he had lost everything in the stock market crash four years earlier. Now he was welcomed back as the keeper of Sears, Roebuck & Co.'s institutional memory and even given his old desk. Until his death in 1948, Roebuck served as the company's official historian and made frequent public speaking appearances at Sears retail stores all over the country.

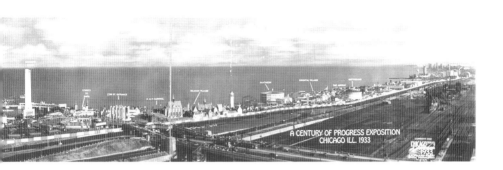

A CENTURY OF PROGRESS EXPOSITION
CHICAGO ILL. 1933

SEARS GOES TO WAR

When Sears, Roebuck & Co. opened its retail store at the Six Corners intersection of Milwaukee, Cicero and Irving Park Roads in 1938, an estimated 99,500 people streamed through the doors on opening day. The only comparable crowd size the store ever saw again was on March 19, 1943, when the Six Corners Sears was invaded by an "attacking force" of 15,000 shoppers after word got out that the store had acquired a supply of war-scarce merchandise. In uncharacteristically droll fashion, the *Chicago Tribune* chronicled the "invasion":

> *The attack started promptly at 9:30 a.m., Sears' opening hour. Elbows and feet swung freely as the sale soldiers pushed their way through the aisles, riding roughshod over any opposition, to establish beachheads in all the aisles. Once through the doors, the forces split into a furious pincers movement. The left flank, marshalling its strength, wiped out the alarm clock sector in 15 minutes; a couple hundred of those prize articles were sold by the brave clerks. The right flank encircled the hosiery counter, seeking 51-gauge rayons. As the vanguard obtained one pair apiece, they climbed over the supporting troops in the rear, and retired to rest. The spearhead stormed the escalators, bound for the sheets on the second floor. When the escalators stopped, they ran up. They went around the rope obstruction meant to keep them in orderly fashion. They brushed aside the store manager, W.W. Simmons, who was trying to maintain order. In half an hour the besieged sheet supplies were exhausted.*

Two years later, Sears built one last freestanding store on the western edge of the city, at 1601 North Harlem Avenue near the intersection of North Avenue. This three-story store, built in 1940 on 356,744 square feet of space, technically falls within the city boundary, though its location is often misclassified as Elmwood Park. The outbreak of war, however, would soon halt Sears's retail expansion not just in Chicago, but all over the nation.

World War II also put an end to Sears's struggling Modern Homes department after the U.S. government appropriated every lumber mill in America, along with production of other crucial materials like rubber and metal. Sears pitched in to help with the war effort, manufacturing farm equipment and holding war bond drives at its stores. The first pages of the spring 1943 Sears Catalog contained a list of items—from accordions to zinc sulphate—that were no longer available during wartime. "To send our fighters the arms and munitions they must have to fight our battles, we at home must do without many of the things we formerly enjoyed," it declared. "And we do it willingly and gladly that Victory may be won."

10

POSTWAR EXPANSION

The Malling of America

By 1946, wartime rationing had left America's retail warehouses all but empty. Now that the war was over and America was entering its greatest period of economic prosperity in living memory, the direction of postwar retail would be decided right here in Chicago. But which of the titans of the industry would take the lead?

Shortages of goods had forced Sears to cancel more than $250 million in civilian orders it was unable to fulfill, and the company was strapped for cash. Its Chicago-based rival, Montgomery Ward, was in even worse financial straits. Ward's president—the very same Sewell Avery who had forced out General Robert Wood twenty years earlier—had run afoul of the National War Labor Board in 1944 for refusing to settle a strike. President Franklin Delano Roosevelt had to order the Department of Commerce to seize the Montgomery Ward plant itself. How it must have secretly pleased the general to see the *Chicago Tribune*'s front-page photo of Avery, his arms folded, being physically carried from his office by National Guardsmen, whom he cursed as "New-Dealers!"

Now Wood would get the last laugh on his old boss once and for all. While Avery "anticipated the return of the Depression after the war and hunkered down, minimizing expenditures and stockpiling cash to outlast the next disaster,"[32] Wood sensed consumers' hunger for goods. After the deprivations of the Depression and the austerity of war, Americans were eager to spend. With everything at stake, Wood bet on growth.[33] He

replenished warehouse inventory, spent $300 million to build 92 new Sears stores and relocated another 212 stores away from urban centers and into the flourishing new suburbs. "After the Second World War," explained Sears project manager Philip Chinn, "Sears envisioned the use of the automobile and the advent of the suburbs, so we were building stores like crazy on the fringe of cities."

So great was the demand for retail expansion that in 1959 Sears formed its own real estate development company for the express purpose of building regional shopping malls from coast to coast. Homart Development Company (named for the cross streets of Sears's Chicago headquarters at Homan and Arthington) would "guarantee [Sears] a place next to the most prestigious department stores in every city."[34] During this postwar retail explosion, the signature tower building design was replaced by the familiar blocklike structure that sprang up all over America in the 1960s, '70s and '80s. The freestanding Sears store became a relic of the past, seldom found outside Chicago or a handful of other major cities.

Homart was responsible for developing several large mall complexes in the Chicago area, including Woodfield Mall in Schaumburg (named jointly for Sears president Robert Wood and the founder of Marshall Field's department store, which was the world's largest enclosed mall at the time of its opening in 1971), Northbrook Court in Northbrook, Orland Square Mall in Orland Park, Louis Joliet Mall in Joliet and Spring Hill Mall in West Dundee. Each of these complexes was anchored by a two-story Sears—designated an "A" store. "B" stores had slightly less floor space and slightly fewer inventory units, but you could still depend on them to carry what you were looking for. These were the most common type of Sears stores built in shopping centers in Aurora, Batavia, Berwyn, Bloomingdale, Bolingbrook, Bourbonnais, Bridgeview, Chicago Ridge, Crystal Lake, Darien, Elgin, Elmwood Park, Fox Lake, Gurnee, Hoffman Estates, Lake Zurich, Melrose Park, Naperville, Niles, North Riverside, Oak Brook, Oswego, St. Charles, Streamwood, Tinley Park, Vernon Hills and Waukegan. "C" stores sold hard goods only—appliances, tools, housewares and electronics—but no clothing or jewelry.

In addition to Homart, Sears developed many other signature brand lines in the postwar period and expanded existing ones. Some you might remember include: Pilgrim clothing (1905–64), J.C. Higgins luggage and sporting equipment (1908–64), Hercules boilers and work uniforms (1908–65), David Bradley lawn and garden equipment (1910–66), Silvertone electronics (1915–72), Harmony House interior decorating system (1940–

Like the best in racing,

The DieHard® that millions of Americans use in their cars is the same brand used in more Indy and NASCAR race cars than all other brands combined.

HERCULES WORK SHIRTS
TRADE MARK

Principal Seams Triple Stitched
Full Cut Armholes
Lined Collars and Cuffs
Vegetable Ivory Buttons

One-Piece Non-Rip Sleeve Facing
Celebrated Hercules Heavy Chambray

A Real Buy!

The World's Greatest Work Shirt
A Feature Among Our Big Value Work Shirts
Hercules Triple Stitched Work Shirts are made of one of the finest heavy-weight chambrays manufactured.

See pages 326 and 327 for Complete Details

530 SEARS, ROEBUCK & CO., CHICAGO, ILL. CATALOGUE No. 118.

30²⁵ $25 AND UP HERCULES BOILERS

OUR NEW LINE OF HERCULES BOILERS IS SUPERIOR TO ANY LINE OF HEATERS EITHER ROUND OR SECTIONAL THAT ARE ON THE MARKET TODAY

WRITE FOR OUR FREE SPECIAL HEATING ☐ CATALOGUE ☐

DURING THE PAST FOUR YEARS, we have been carefully experimenting with, and studying the good and bad points of all the boilers on the market in order to secure for our customers a boiler that would combine all the advantages of the round and sectional boilers. The round boiler has advantages in the way of compact fire pot and simplicity of construction, but it lacks the superior advantages of the sectional boiler, which are a long fire travel, increased heating surface, and the correct proportions between the heating surface and grate surface. We have at last secured a boiler that meets all of these requirements, a boiler that will stand the most critical examination and tests, one that we know that will give perfect satisfaction to our customers, and one that we will guarantee absolutely. The fire pot is deep and the flues are large so it will do its work economically and with the least attention.

FOR HOT WATER HEATING this heater is superior to any small heater on the market as it has a perfect interior circulation, and this is also especially advantageous for steam, as the steam is more easily generated and is quickly separated from the water, so that the water is not carried up into the pipes with the steam. The heater is thoroughly tested before leaving the works and is made up and shipped in two parts, base and grates in one, and the sections in the other, which makes it easy to erect. Its compact form enables it to be carried into a building as easily as a radiator.

THE STEAM BOILER is furnished complete with all steam trimmings, such as steam gauge, water column and damper regulator and safety valve. These are not necessary with a hot water boiler. All boilers are furnished complete with fitting tools such as poker, hoe and flue brush.

From the heating material listed on this and the following pages, you can select everything necessary for the complete installation of hot water and steam heating plants.

However, if you want us to estimate on a complete plant for you, or if you want more detailed descriptions of our heaters than the space here permits us to give, or if you want larger capacity boilers than shown on this page, then send for our Free Special Catalogue, "Hercules Systems of Home Heating." When we send you this free special catalogue, we will also send you a plan blank and estimate form which you can fill out, showing the style and size of your house, and what rooms you want radiation in. Upon receipt of this plan we will furnish you an estimate of the plant complete, just what is required and what it will cost you.

Top, left: Die-Hard ad, circa 1986. *Northwestern University Archives.*

Top, right: Hercules work shirts advertisement. *Northwestern University Archives.*

Bottom: Hercules boilers advertisement. *Northwestern University Archives.*

NEW Silvertone
◄◄◄ The Outstanding Radio

YOUR CHOICE of
Seven-Tube A. C. Screen Grid
or Eight-Tube Improved
Neutrodyne A. C. Radio

$100
Beautiful
Cabinet
Complete
With
Tubes

NOTHING ELSE TO BUY

A MASTERPIECE
In Cabinet Designing

So that you might enjoy either your Screen Grid or Neutrodyne Silvertone Radio through the medium of the finest furniture, we went to America's foremost sculptor designer, Lorado Taft, member National Committee of Fine Arts, American Academy Arts and Letters, National Sculpture Society, honorary member American institute of Architects. Mr. Taft, famous on two continents for his artistic contributions, has approved the SILVERTONE Champion as a masterpiece in cabinet design.

AN ACHIEVEMENT
In Radio Engineering

The radio world knows the magic of the name, Alexander Senauke, B.S., M.E., E.E., inventor, consultant, lecturer, radio engineer and faculty lecturer on radio communication in one of the largest universities in the world. He, coupled with our own research and engineering staff, has developed these SILVERTONE Champions—the New All Electric Seven-Tube Screen Grid Receiver and the New Improved All Electric Eight-Tube Neutrodyne. Scientifically correct in every detail, these new receivers are remarkable achievements in radio egineering.

30 DAYS' TRIAL
$15.00 DOWN
$10.00 A MONTH

AWARDED THE HONOR
of Opening This Great-Catalog

Because they so adequately tell the story back of every piece of merchandise offered in this new catalog, the SILVERTONE Champions have been selected by us to "open the books." Superior in value, beautiful in cabinet design, new and correct in engineering principles, the SILVERTONE Champions represent the effort, the study, the buying power, mass production and mass distribution behind every article we sell. The SILVERTONE Champions are Sears-Roebuck, and Sears-Roebuck is proud to present them to you—proud to have them as the first merchandise offering in this new catalog.

4

SEARS, ROEBUCK AND CO. ⟩WLS⟨ *The World's Largest Store*

Silvertone radio circa 1933. *Northwestern University Archives.*

68), Roebucks work clothing (1949–present), Die-Hard batteries and tools (1967–present), Toughskins jeans (1971–present) and Cheryl Tiegs women's wear (1981–89).

Some of Sears's most recognizable brands had a story behind them.

KENMORE/COLDSPOT (1927/28–PRESENT)

Sears introduced the Kenmore brand of washing machines in 1927 and Coldspot refrigerators the following year. Both product lines greatly expanded after the war to include dishwashers, garbage disposals, ranges, washing machines, dryers and much more. After 1976, Sears discontinued the Coldspot brand name and sold all large kitchen appliances under the Kenmore label.

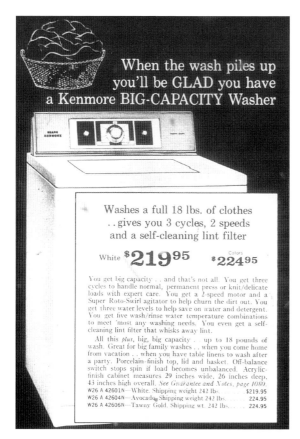

Kenmore washing machine, circa 1973. *Northwestern University Archives.*

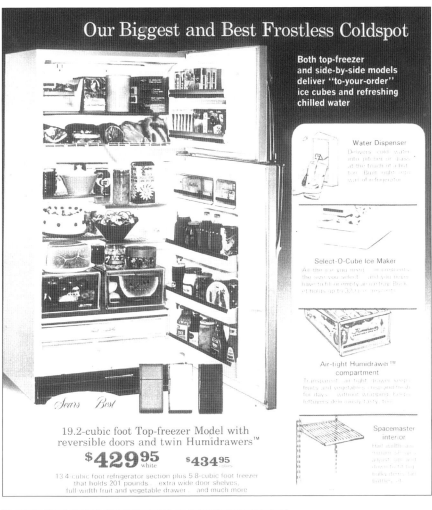

Our Biggest and Best Frostless Coldspot

Both top-freezer and side-by-side models deliver "to-your-order" ice cubes and refreshing chilled water

Water Dispenser

Select-O-Cube Ice Maker

Air-tight Humidrawer™ compartment

Spacemaster interior

19.2-cubic foot Top-freezer Model with reversible doors and twin Humidrawers™

$429⁹⁵ white **$434⁹⁵**

13.4-cubic foot refrigerator section plus 5.8-cubic foot freezer that holds 201 pounds... extra wide door shelves, full-width fruit and vegetable drawer... and much more

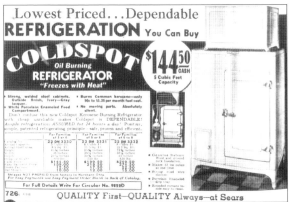

Lowest Priced...Dependable
REFRIGERATION You Can Buy
COLDSPOT
Oil Burning
REFRIGERATOR
"Freezes with Heat"

QUALITY First—QUALITY Always—at Sears

Above: Coldspot refrigerators, 1973. *Northwestern University Archives.*

Left: 1933 Coldspot ad. *Northwestern University Archives.*

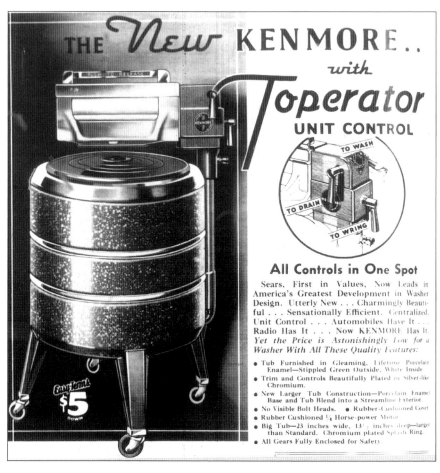

Above: Kenmore washing machine, 1933. *Northwestern University Archives.*

Left: Kenmore ad, 1988. *Northwestern University Archives.*

Craftsman, "The Standard of Quality" (1927–2017)

Wood wasn't the only one who recognized the automobile as a game-changer. Tom Dunlap, head of the hardware department, knew that professional mechanics, not "regular" folks, were now Craftsman's biggest customer. Knowing the pride and care that mechanics lavished on their tools, Dunlap added chrome plating and colored trim to the tools. This baffled his old boss, Arthur Barrows, who had launched the Craftsman line in 1927. Barrows didn't see the point of decorating a socket wrench that a mechanic would "slug the hell out of," but even he couldn't argue with the

Craftsman, 1933. *Northwestern University Archives.*

900 PIECE Professional Mechanics' Tool Set

Don't miss these 2 great ways to save
on America's best selling Mechanics' Tool Sets!

Tool Set alone
Save $930
$2899
$97 MONTHLY, see page 326A

Tool Set with PRO SET Chest and Roll-a-way
Save $1230
$3599
$120 MONTHLY, see page 326A

PRO SET Chest and Roll-a-way
$999⁹⁸
$34 MONTHLY, see page 326A

Craftsman tools, the envy of every mechanic. *Northwestern University Archives.*

600 percent increase in sales the following year. Craftsman tools were now more than just practical and easier to clean; they were also objects of beauty, worthy of display. No longer would they be relegated to dark, grimy tool boxes; countless Americans have grown up with a set of Craftsman tools hung in a place of honor over the workbench or laid out lovingly on display

racks. All Craftsman tools were guaranteed to last a lifetime or be replaced absolutely free—a claim that was proven good in 1979, when a customer returned a tool set purchased fifty years earlier and got a brand-new set in exchange.[35] In January 2017, Stanley Black & Decker bought Craftsman for $900 million.

ALLSTATE (1931–95)

If Julius Rosenwald had lived just one year longer, he would undoubtedly have supported Wood's idea to sell automobile insurance by mail. But since his death in January 1930, Wood had to pitch his idea to "a reluctant board of directors that wanted to say 'no' but yielded to Wood's plea that if they had any respect for his managerial abilities they would give him a chance to prove his point.…[By] the late 1970s, the profits from the Allstate insurance business exceeded total retailing profits."[36] The Allstate brand name also appeared on garage door openers, fire extinguishers, motor scooters, camper shells, auto accessories (which at the time included seat belts) and even the Allstate, a short-lived six-cylinder automobile manufactured by Kaiser-

Allstate auto insurance ad, 1933. *Northwestern University Archives.*

Above: Allstate tire ad, 1933. *Northwestern University Archives.*

Left: Allstate insurance, 1933. *Northwestern University Archives.*

The Allstate brand appeared on all things automotive, not just insurance. *Northwestern University Archives.*

Frazer. Sears's attempt to enter the auto industry turned out to be a rare misfire, and the Allstate was manufactured only in 1952–53. Sears divested from its signature insurance company in 1995.

THE GOLDEN AGE OF SEARS

Geneneral Wood's daring gamble versus Mr. Avery's more conservative postwar strategy became a legend of U.S. retailing," says marketing researcher Kate Fitzgerald. Sears was not only the best place to shop; it was also the best place to work. Wood, a staunch conservative, nevertheless embraced a version of Julius Rosenwald's philosophy of sharing, which he applied to Sears policy at all levels. Wood wasn't motivated by altruism or social justice; it was simply good business, he felt, for Sears to corner the market as "the workingman's friend." The tax structure and labor market of postwar America "were combining to make a sharing of sorts the national default. The federal income tax throughout the mid-century Sears golden years subjected individual income over $200,000 to a tax rate that hovered around 90 percent. That left top executives like Wood with little incentive to feather their own nests."[37]

As long as Wood held the reins at Sears, management salaries were kept below the average paid by Sears's competitors, and executives were permitted no special perks. But the issue of salary was secondary to the benefits of joining the Sears family. Wood felt that offering insurance, vacation time, sick pay and separation allowances helped cultivate a sense of loyalty and trust among Sears's workforce—and kept unions away.

Wood also expanded and restructured Sears's profit-sharing plan. Any employee who worked at Sears for more than a year was eligible to join. Once an employee had worked fifteen years, the company would "put into the 'Savings and Profit Sharing Pension Fund of Sears, Roebuck and Co.' a

"Overcast over Sears Tower." *Photo credit: Walter Kadlubowski.*

sum that equaled five times the employee contribution." This money would be invested in Sears stock and other assets, and the dividends were paid to participants. Veteran employees would routinely receive more from profit-sharing payouts than from their wages. Janitors making $40 a week could waltz into retirement with $2,500 in savings. As a result, the bottom 90 percent of American households saw their incomes soar from an average of $10,513 in 1940 to $26,665 in 1960. During Wood's tenure, Sears held the highest employee-share percentage in America, with one-third of the company's shares held by current or retired employees.

By the time Wood retired from the Sears board of directors in 1968, there was no question that he had given Sears an entirely new identity and position in twentieth-century American life. Thanks to him, no competitor could touch Sears's sales or reputation for excellent quality and customer service. Sears's base of operations now needed even more space than the forty-acre Great Works provided.

In the first century of its existence, Richard Sears's retail empire had expanded across the entire Western Hemisphere. Now, as the company's second century approached, Sears turned its eyes to the skies.

PART II

Rise and Fall (1970-2018)

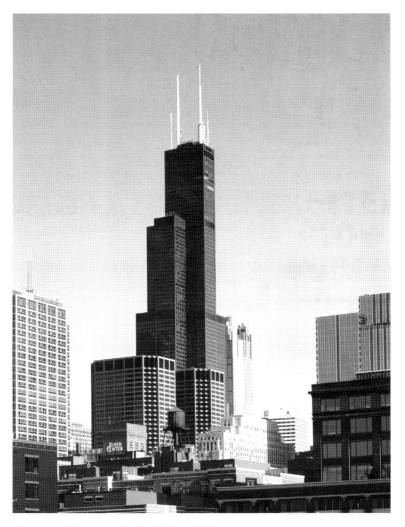

Always watching over the city. *Library of Congress.*

THE SEARS TOWER

Ask any Chicagoan the name of the tallest structure dominating its skyline, and you're likely to get the same answer: just as Macy's on State Street will always be "the old Marshall Field's," the building at 233 South Wacker Drive has always been the Sears Tower, and it always will be.

You might almost be forgiven for thinking of it, at first glance, as just another tall building. For its first twenty-five years, the Sears Tower held the title of the tallest building in the world. It's still the second-tallest building in North America and the Western Hemisphere, though that's not a catchy slogan for souvenir T-shirts. Regardless of which building(s) may hold the title of "world's tallest" at any given moment, what cities are *really* competing for is bragging rights—which Chicago already has plenty of. The Sears Tower required a massive coordination of ingenuity and effort that broke records and set new industry standards for decades to come. Sure, Petronas Towers in Kuala Lumpur may have stuck on a few spires to be officially thirty-three feet taller than Chicago's former record holder, but where's the innovation or human drama in *that*?

The full story of the Sears Tower is an epic worthy of a much longer book. The most important part of this story, like the city itself, is the people who made it happen. You'll meet several of them here, from the architects on the ground to the builders in the sky.

The Chicago skyline at night, 1930. It's beautiful, but something's missing.... *Library of Congress.*

The legend that Sears had planned from the outset to build the world's tallest building took hold even before ground was broken. After it was done, Sears chairman Gordon Metcalf made it sound easy: "Being the largest retailer in the world, we thought we should have the largest headquarters in the world."[38]

At the beginning, however, no one was thinking about making international headlines or breaking world records. Sears had simply outgrown its sixty-year-old Great Works headquarters on Homan Avenue, and it was time once again to move to new headquarters. "Sears's growth was just phenomenal," said Philip Chinn. "We'd been number one for a long time, and we far exceeded the competition."

But before pencil could touch drafting paper, Sears had to calculate how much space it needed. For this, it hired SLS Environetics to analyze the space Sears was currently using and to calculate the amount of space the company would need over the next thirty years. Environetics interviewed hundreds of Sears employees, inventoried all furniture and equipment and analyzed traffic patterns at the Great Works on Homan Avenue. Then it did something that, in 1969, must have seemed like science fiction: it fed its data into a computer.

The result: Sears needed three and a half million square feet to continue operations at its current size. At its current rate of growth, it would eventually need four and a half million square feet.

The next question was: where to build it?

WHAT HAPPENED
TO QUINCY STREET?

Despite the trend of many major businesses moving their operations to the suburbs or less populated areas, Sears didn't consider setting up new headquarters anywhere but in the city of its birth. Its seven thousand employees who worked at headquarters (or "parent") now commuted from every suburb, and the company had established relationships with local retailers that went back decades. Bruce Graham, later the chief architect on the Sears Tower project, lauded Sears's decision to stay in Chicago: "For a colossus like that to have more moral responsibility than smaller factories that have moved out is remarkable."[39]

Still, not everyone was pleased with the company's decision to build new headquarters instead of existing in the old one. The North Lawndale area around the Great Works had been hit hard by "white flight"; by 1960, 91 percent of the residents were black. As the population density increased, the city failed to invest in maintaining the neighborhood's infrastructure. Conditions in North Lawndale were so poor that, in 1966, Martin Luther King Jr. moved to a dilapidated building at 1550 South Hamlin. The top-floor flat became the base for the Chicago Freedom Movement, King's campaign to "eradicate a vicious system which seeks to further colonize thousands of Negroes within a slum environment."[40] After King's assassination, residents and business owners in North Lawndale could no longer get insurance, and the neighborhood experienced "a calamitous free-fall. The very next year, Sears announced it would build a sparkling new skyscraper that would allow it to flee the neighborhood, leaving behind in North Lawndale a wasteland that it now made even more desperate."

Nonetheless, the decision was made to move headquarters to a new site. After much deliberation, the choice came down to two locations.

One was on Goose Island, an artificial island situated between the Chicago River and the North Branch Canal, several miles northwest of downtown. It had plenty of freeway access, but the gritty industrial area was surrounded by tanneries and smelting works—hardly a location Sears would have considered if it had been planning to build the world's tallest tourist attraction from the outset.

The other site—and the least attractive one, according to Chinn—was a three-acre lot in the former garment district, on the southwest corner of the Loop between Adams, Jackson, Wacker and Franklin. It was ideally located near the suburban rail and bus lines, but the area itself was, as the polite term puts it, "blighted." Closed storefronts were scrawled with graffiti, and sketchy transactions took place in broad daylight along Lower Wacker. Nevertheless, Sears began buying the properties occupying this latter site, including a one-block stretch of Quincy Street between Wacker Drive and Franklin Avenue, for $2.7 million ($17,655,564.99 today).

Eighty-two years earlier, Richard W. Sears had set up his first watch business just a few blocks away. Now the company that bore his name was about to rise above its competition in a way that would make the world take notice.

There was just one limitation to the downtown site: Sears needed four and a half million square feet, and the only direction to build was skyward.

14

SWEET HOME CHICAGO

Sears's loyalty to Chicago was more than just sentimental. The city renowned for its clashing chorus of styles and schools of design, the birthplace of skyscrapers, "an architectural miracle that is to twentieth-century urban planning what Venice must have been for the fifteenth century,"[41] is a pretty good place to find architects.

And it found them.

"[Skidmore, Owings & Merrill LLP] were the preeminent builders of corporate office buildings at that time," said Philip Chinn. "They had done a number of great buildings, and they had the most talent." This talent included senior design partner Bruce Graham, whose many projects included the Chicago 21 Plan to reroute Lake Shore Drive, expand the museum campus and develop Navy Pier. Another partner was Fazlur Khan, the famed structural engineer who had absorbed Hardy Cross's advice on "structural empathy" at the University of Illinois. "I put myself in the place of a whole building, feeling every part," Khan once told the *Engineering News-Record*. "In my mind I visualize the stresses and twisting a building undergoes."[42] It was Khan who had envisioned the braced-tube design of the one-hundred-story John Hancock Center, on which Graham had been chief designer.

John Zils, a structural engineer at SOM, remembers the "dynamic energy" that resulted whenever Graham and Khan put their heads together to push the boundaries of imagination and achievement. One day at lunch, Zils watched as Khan attempted to explain to Graham his concept

for a building with a bundled-tube system. To anyone else, it might have sounded impossible. As Khan spoke, however, Graham took out a handful of cigarettes. He clutched them loosely together, arranging them at different heights in his fist.

"Like this?" he asked.

"That's exactly right!" Khan exclaimed.

Graham and Khan were pioneers in tube construction, which allowed for "supertall" structures over 300 meters (984 feet). Until approximately 1960, most tall buildings were erected using long spans of widely spaced steel columns, which need internal bracing and support columns to bear their weight. Bringing the exterior columns closer together, on the other hand, allows them to act as a weight-bearing wall on the perimeter of the building. Most of the building's weight is borne by the outer walls, rather than by interior support columns. The building is essentially constructed as a hollow tube, allowing open floor plans that maximize space. However, Zils explains, the tube concept starts to become inefficient in a building the size of the Sears Tower, because the tubes themselves are so wide and deep. Sears planned to occupy the first fifty floors and lease the remainder of the space. The problem was that, while Sears might easily find use for fifty thousand square feet of office space, not many other tenants would want to lease even half that much.

The solution was for Graham and Khan to design a series of nine square tubes, bundled together in rows of three to form an upright cubic rectangle. Two of the tubes would rise to the fiftieth floor, with three more continuing to the sixty-sixth floor and two more to the ninetieth, with only the last two tubes rising 110 stories above the city streets. Staggering the tube heights this way solved Sears's marketability problem. As the tower rises, the space gets narrower, and smaller floor plans with perimeter offices are much more attractive on the leasing market. This design was hailed as "a masterful blending of advanced engineering concepts and rational adjustment of architecture to the site and the marketplace."[43]

And there was another reason to go with this bundled-tube design: getting four and a half million square feet into an increasingly constricted space would mean a very, very tall building indeed—just slightly taller, in fact, than the World Trade Center towers currently going up in Manhattan.

"THE BRASS RING"

Richard Halpern, the top Morse-Diesel construction executive assigned to the Sears project, is remembered as "one of the last true master builders." His other Chicago projects include Navy Pier, McCormick Place, the Harold Washington Library, One Magnificent Mile, the Museum of Contemporary Art and the expansion of O'Hare International Airport. Halpern served as the chief executive of the tower project, and the top people of all the companies involved—Alcoa Aluminum, American Bridge, the Ironworkers Local Union No. 1—all reported directly to him. "Every contractor was the top executive or chief operating officer of the organization," Halpern remembered in a *Modern Marvels* documentary about the construction of the Sears Tower. "We wanted to get something done, [and] together we could get it done."

Halpern was present at the meeting in which Sears executives considered a number of different cardboard building models representing different designs. Architect Bruce Graham—Halpern described him as "a consummate salesman"—produced one more model from a bag and placed it on the table. Carved from solid walnut and about eighteen inches high, the model was an asymmetrical design of nine bundled tubes, "a cubist's dream of the Matterhorn."[44] a compelling visual to underscore Graham's suggestion that "we were so close to the world's tallest building that we should consider going for the brass ring."

"The Sears executives almost broke into applause," Halpern remembered, smiling. "There were smiles all around the table."

Sears announced on July 27, 1970, that it would erect the world's tallest building in Chicago: 1,450 feet, the height limit set by the Federal Aviation Administration. Hal Iyengar, a senior structural engineer at SOM, remembers that "most of the public excitement came from the fact that we were one up on New York." During the thirty-three months it took to lay the foundation and raise the steel skeleton, Halpern recalled, rumors kept circulating that New York planned to add floors or a penthouse to the World Trade Center in order to take back the "world's tallest" title from Chicago.

This time, the Second City was determined to come in first.

A TALL ORDER

Halpern later recalled that there were never any finished, working drawings until close to the day they would be needed for the next phase of the project. Thus the foundation drawings were finished first, then the steel structure, the elevators and so on. Richard Tomlinson, Halpern's protégé, recalls being "a tiny young babe in architect diapers" when he was "volunteered" for work on the Sears Tower project. "There were many updates on drawings that needed to be done, and they always needed it yesterday," he says. "That's how you get volunteered, when you're sitting close by. It was exciting because it was the tallest building in the world, in *our* city."

"The city of Chicago was as much a part of the team as SOM, Morse Diesel, American Bridge, and the other contractors," Tomlinson explains. Building codes at that time simply didn't anticipate structures the size of the John Hancock Center or the Sears Tower. This made it difficult to secure building permits that addressed specific issues in the building designs; sometimes, there *was* no building code that applied. "The city was very collaborative in working with us to grant those permits and ensure that fire and safety accommodations were addressed. They did this for both the Sears and the Hancock."

The tower was also built to consolidate Sears operations into one building, according to architect David Hoffman: "There were a lot of companies in the Sears Tower that directly serviced Sears: their law firm [Latham & Watkins], Allstate, and others. They really pulled a

lot of tenants into the building to act as their service providers." Sears historian Dennis Preisler agrees that "the Tower had a dramatic impact on the economy of the city." South Wacker Drive had become something of a ghost town, with little to draw either commercial or tourist traffic. Now businesses rushed to, as Preisler puts it, "revitalize the area," grabbing up real estate near the square block that would soon be home to the world's tallest building. So much traffic flooded the area that the city of Chicago extended Wacker to Lake Shore Drive the year after the tower was completed.

By June 1971, the foundation was complete. It was now time for the ironworkers to do their job—"a brutal job, to say the least," says Jo Ann DeKlerk, whose husband, Jack, was an ironworker with American Bridge construction company. They had married in 1967, two months after Jack's brother Bill had married Jo Ann's girlhood friend Mary. The two couples bought homes a block apart in Harvey, Illinois, and often went fishing and camping together. Jack had a good salary and benefits working as a repairman for photo finishing machines, but he quit one day when his boss wanted him to overcharge a customer for parts. He might not have known it at the time, but this ethical stand was the start of the path toward the job that

Jack DeKlerk, ironworker.
Photo courtesy of Jo Ann DeKlerk.

had been Jack's lifelong dream: ironworking. Now Jo Ann's uncle Ronnie Polk, a Business Agent with the Ironworkers Local No. 1, told Jack how to apply to apprenticeship school. Working full-time ground construction during the day to support his wife and baby son *and* going school at night would leave little time for relaxation over the next four years—but then Jack never minded hard work.

The opportunity to work on the world's tallest building was "extremely exciting, hard to top in your career," says David Crowell, a young Morse-Diesel employee who found himself working as assistant superintendent

on the Sears Tower from late 1972 until May 1973. Every detail—the number of workers on-site at any given time, timing the delivery of truckloads of raw materials at different unloading points, the scheduling of the work itself—had to be worked out in advance. Chief among the logistical concerns was how to go about raising a 110-story building in the heart of a busy downtown metropolis. Unlike the Great Works, there was no room for storage on the site.

American Bridge was determined that progress on the Sears Tower would never be delayed due to truckloads of material being stuck in city traffic. "The raw materials like sand and gravel [for the concrete plan in the structure's lower level] came in via lower Wacker at night," Crowell recalls. "We had a lot of different access points, from lower Wacker to Daley Plaza, dedicated to various deliveries." This ultra-efficient delivery system left no room for on-site storage; all materials to be erected that day needed to be delivered, and everything delivered had to be erected that day.

"There were a lot of firsts on the building," says Crowell with pride, "everything from the exterior glass to the plumbing. All the techniques we used were being invented as we went." Innovations in safety and building methods often overlapped. Together, Richard Halpern and Ray Worley,

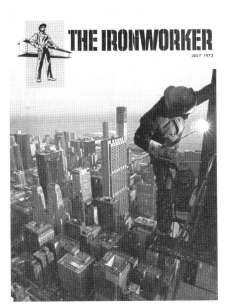
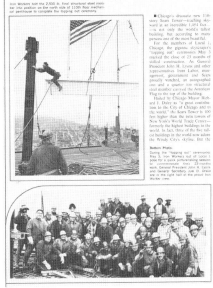

Left: The *Ironworker* magazine dedicated its July 1973 issue to the Sears Tower. *Image courtesy of Jo Ann DeKlerk.*

Right: *Ironworker* magazine page. *Image courtesy of Jo Ann DeKlerk.*

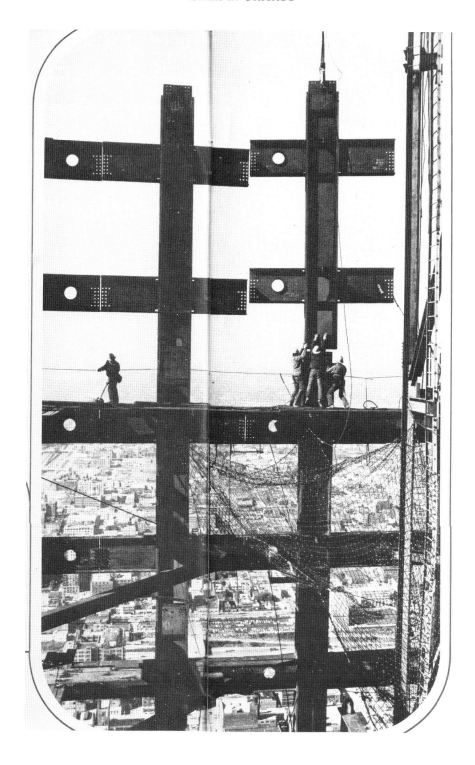

the Sears Tower's general contractor, developed a jump-lift elevator, using a crane to raise the temporary elevators in the building's permanent elevator shafts as each floor was finished. This was far safer than using construction elevators on the outside of the building. Wire mesh "wind cages" held drywall and sheet metal to prevent them from blowing off the building in one of the windstorms that sometimes happened as low as eight stories. These and many other practices the two men developed "became standard practice in construction from that point on," says Crowell. "[The Sears Tower] became a model of efficiency in building tall buildings."

The steel columns and girders were welded together at the steel plant where they were manufactured and then delivered on trucks to the building site. Ironworkers then hoisted each "Christmas tree" unit up the structure and bolted them into place. This was considerably safer, easier and faster than welding everything on-site. Each tree unit was numbered sequentially, loaded in the order it would need to be taken off the truck and installed at the site.

"The steel system was just wonderful," exclaimed Halpern. "It went together smooth as silk." Hal Iyengar summed up the process as "no more than putting together a series of tinker toys."

That might technically be true, but try telling it to the guys a thousand feet up in the air.

Opposite: Ironworker magazine photograph. Image courtesy of Jo Ann DeKlerk.

COWBOYS OF THE SKY

Just as he completed his apprenticeship, Jack DeKlerk faced the kind of dilemma that most newly minted journeyman ironworkers would envy: he was offered two jobs. One was doing construction on one of Chicago's endlessly-under-construction expressways; the other was a chance to construct the tallest building in the world. Without hesitating, Jack chose the Sears Tower. "He said he wanted to work with a boss named Baxter," his wife, Jo Ann, remembers, "and Baxter was running the construction of the Tower."

Howard Baxter, American Bridge's superintendent on the Sears Tower, was legendary in the construction industry. Scott Rowell, an American Bridge ironworker who became an elevator constructor in the Sears Tower and spent twenty-three years maintaining its 104 elevators, recalls Baxter as a "genius" and a "leader of men" who had the foresight to hire film crews to document the construction of the world's tallest building. Men competed to work for Baxter, and being selected for one of his jobs was a tremendous opportunity. Workmen of all trades came from all over the country, eager for the "bragging rights" of working on the Sears Tower.

John Porzuczek was in the second year of his apprenticeship when he started as a "gofer" on the Sears Tower in 1971. The raising gang foreman, Marcell Eck, always liked to see a good day's work—and he liked how hardworking Porzuczek was. Throughout his career, Porzuczek says, "I believed in giving the company their money's worth." As the months went by, he started to get hands-on experience with the raising gang and was assigned as Jack DeKlerk's partner in July 1972.

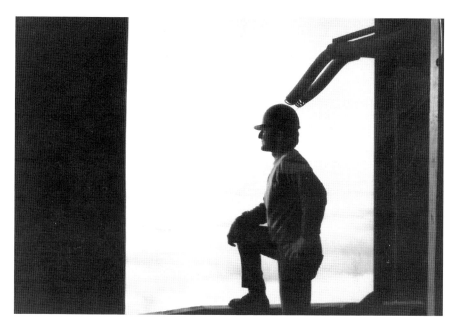

Ironworker John Porzuczek surveys the city from the 109ᵗʰ floor. *Photo credit: Richard Gumber and Scott Rowell.*

"Those guys [on the raising gang] were the best ironworkers in the country," Rowell says, the pride in his voice as strong today as it was forty-five years ago. "The cream of the crop, over three hundred of 'em, and not one of 'em you ever had to tell anything to twice. These guys were *really* tough."

Back in 1906, Theodore Starrett had written, in his typical florid style: "The enthusiasms of the army that is engaged in a work like this building of the Sears-Roebuck buildings is something thrilling. It is like the ardor of battle. The whole organization is like a troop of cavalry in a charge under a good leader. They do not care what is ahead of them. The watchword is 'Get there,' and get there they do, even if they are killed in the act."

The army of ironworkers who competed to work on the Sears Tower job shared the same "Get there" philosophy as the brickmasons of sixty-five years earlier. Simply put, nothing scared them—not the daily risk of death or injury, and certainly not walking the steel. It was terrifying and dangerous work, but that was what guys like Jack and John and all the rest of the ironworkers loved about the job. "Nowadays it's all done with lift baskets," says Porzuczek almost wistfully. "It's not like how it used to be."

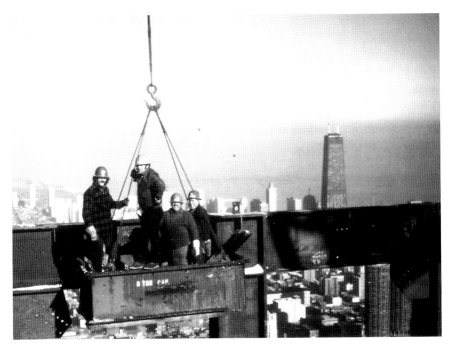

The raising gang at work. *Photo credit: Richard Gumber and Scott Rowell.*

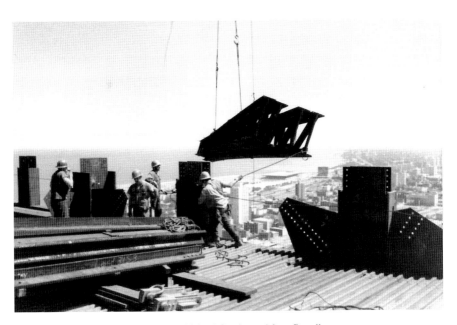

More raising gang work. *Photo credit: Richard Gumber and Scott Rowell.*

The system of preassembling and numbering the girders not only solved problems of ground transport and storage, but it also made the ironworkers' job a bit easier. "Every piece was numbered and loaded on the truck at the right time," recalled American Bridge crane operator Richard "Dick" Gumber, "so that it would be the next piece to go up on the building. It took a lot of coordination between the fabricators and shipping and the truckers to make it all run smooth, and everything had to stay in line." Ironworker Vic Mugica remembers trucks lined up along Canal Street to the south, "like Rommel's army. They'd come in and we'd unload it, boom, that truck would go, they'd call in another truck."

At this assembly-line rate, they could finish two floors per week, if conditions cooperated. Temperatures that were pleasantly mild at street level could be as much as twenty degrees colder at the heights the men were working. They were required to wear loose clothing, so most opted for flannel shirts. Thermal underwear was strictly prohibited, since it would cause them to sweat in the shanties before they stepped back out into the freezing winds. John Porzuczek remembers crawling along the steel beams in gusts of wind that sometimes reached up to eighty miles per hour. They learned not to touch their eyelashes or eyebrows if they turned white, or the frozen hair would simply break off.

Rain, snow or temperatures below ten degrees Fahrenheit would halt work. "Every morning the ironworkers' steward would go up early and check the weather on top, to see if it was fit to work," Gumber remembered. "Sometimes it would be nice down below, sun shining, not a lot of wind, and the steward would come down and say 'No work today, boys.'" Between August and December 1972, conditions did not permit a single uninterrupted week of work. The longest was a five-day stretch without work—or pay—when all the steel was iced over with frozen condensation from the lake, which the men called "witch hazel."

The logistics of meeting the basic needs of the hundreds of tradesmen under these conditions required some innovation as well. Service trailers, heated in winter, provided shelter where the men could eat and change clothes. The portable toilet facilities were changed out twice a week. First-aid offices were placed vertically at strategic points throughout the steel-frame structure so an injured worker could be treated without being moved too far. Many men took their meals off carts on cable-drawn pulleys rather than using precious time to get down to ground level and back up again. Some, however, preferred a faster way.

Left: Assembling the tower's massive antennae. *Photo credit: Richard Gumber and Scott Rowell.*

Below: Sears Tower antennae under construction. *Photo credit: Richard Gumber and Scott Rowell.*

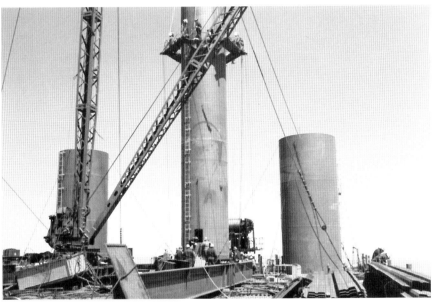

"The older guys didn't go down for lunch," John Porzuczek recalls, in order to save the time of getting off the building and getting back up again. But "back then, we were young and dumb." Early on, the younger men on the raising gang would have a "little contest" at lunchtime, challenging each other to slide down the cable used to lift the hoist engine through the hole in each floor—not a very big hole, just barely wide enough to fit a man. The cable was extremely greasy, and the men didn't try this too often. Another time, the workers arrived on-site only to be told that the lifts weren't working. They had two choices: climb fifty floors, or go home. Since going home meant losing a day's pay, everyone climbed up.

Still, such stunts were exceptions rather than the rule. "[Foreman] Marcell [Eck] always made sure we were safe," Porzuczek says. With the eyes of the world on them, the ironworkers were determined to prove what the City of Big Shoulders could do. Dick Gumber recalled breaking the record for tonnage set in a single day: more than one hundred truckloads of steel.

18

CLOSE CALLS

There were accidents, of course. Despite every safety precaution in the construction industry, even those invented specifically for the Sears Tower, the sheer magnitude of the project increased the likelihood that something, somewhere, would eventually go wrong.

One spring afternoon in 1973, John Zils received a phone call around 4:30 p.m. from SOM's field representative: "I think you better come out to the building right away," the rep said nervously. "Something's happened here."

As one of the tree units was being lifted high above Adams Street, one of the pulleys in the crane failed, cutting the cable and sending the two-story column crashing down. "There's no sound like that sound," says David Hoffman. "The worst sound you can imagine is steel crashing down."

Dick Gumber and some of the ironworkers were sent to "get everything straightened out so that it wouldn't make a big scene for the news media." Amazingly, despite workers pouring onto the city streets at the end of the day, no one was hurt. The worst of the damage was caused by the cable landing on the hood of a taxicab.

"That poor cab driver," ironworker Tommy Stack remembered. "I don't think we could get his fingers off the wheel…he happened to be just sitting there in traffic, and all of a sudden—*brrroom!*"

"They said the passenger in the back seat wet her pants," Gumber added cheerfully.

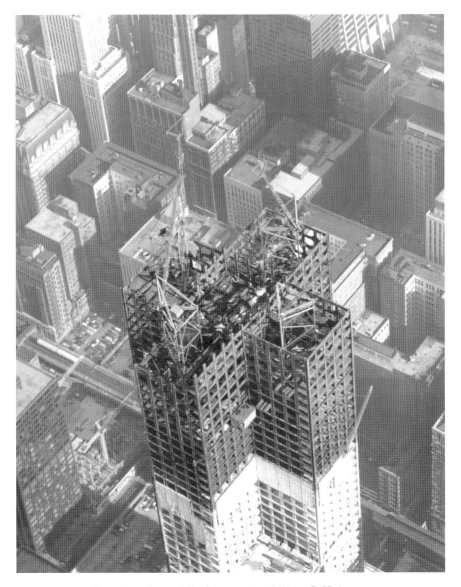

Two floors a week adds up after a while. *Image courtesy of Jo Ann DeKlerk.*

THERE WERE OTHER CLOSE calls as the Sears Tower rose higher and the project neared completion. On April 5, 1973, some interior scaffolding planks blew from the 108th floor and fell onto Adams Street, shattering a window in the Fashion Trades Building (now the West Loop location of Level Offices) and

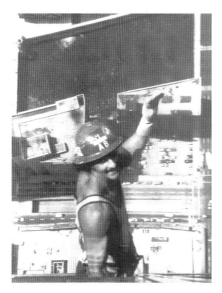

Ironworker Scott Rowell lends a helping hand out the window of the Sears Tower. *Photo credit: Scott Rowell.*

injuring two women struck by wood fragments and shards of glass. There was also a close call involving a glazier who somehow slipped and fell *outside* the building, clinging to an exterior cable and dangling more than eighty stories above the street.

"The vice-president and president [of Sears] wanted him rescued before the news crews got there," recalls Scott Rowell. Earl Towery, the SOM engineer who oversaw the Sears Tower project, ordered Rowell to take out a window to rescue the man. When Rowell refused, Towery urged him harder, thinking Rowell was objecting to performing a union task. But instead, Rowell reminded him that removing a high-rise window with the elevators still running would be like breaking the window of a commercial jet in flight: the sudden change in pressure could sweep men out the window to their deaths.

"Oh my God, that's right!" Towery cried, and rushed to shut off the elevators.

"So," says Rowell, "I put on the suction cups."

Carefully, Rowell removed the quarter-inch glass pane, and the rushing wind greeted him. He tried not to look down at the cars that crawled like ants along the paved grid of the streets. He laid the pane very, very gently on plywood. Then he reached out to the hapless glazier clinging to the cable below—who wouldn't (or couldn't) release his grip. Ordering two other workers to hold his legs, Rowell hung out the window as far as his waist, urged the terrified man to grab his hand and then shouted to the men to pull them back inside.

It wasn't easy. "He was fighting me," says Rowell, "and I had to hit him in the face." The glazier and his partner were fired, the installed windows removed and plans changed to re-insert them once the steel structure was complete.

TRAGEDY

And there were deaths. Six in all, beginning in October 1972, when welder Walter Kettleston fell to his death, despite the "circus nets" that were placed every two floors inside.[45] His partner on the job, who was also his son, slid down two stories of steel beams to cradle his father's head in his arms before he died.

On April 11, 1973, four men employed by the elevator division of Westinghouse Electric were working on an elevator platform in one of the shafts at the forty-second floor, cleaning oil from the rails. Oldest among them was fifty-two-year-old Robert Wiggins. That spring, he and his wife, Hilda, with their four-year-old daughter, Amy, lived in an apartment in Park Ridge while their home was being remodeled. Leonard Olson, forty-four, had been living in a hotel on Leland Avenue for about a year. Twenty-year-old Larry Lucas lived with his parents in Lincolnwood. William Walsh, only a year older, had earned a Bronze Star and three Purple Hearts in Vietnam, married his high school sweetheart and had a two-year-old son, Billy. Lately, though, there had been problems in the marriage, and his wife, Jean, was living with Billy at her parents' home in Elmhurst. But they'd been able to work things out and were planning to move back in together that very week.

The steel rails the men were cleaning had been coated with oil to prevent rust during shipping. Tragically, no one realized that the solvent they were using was flammable. Something—most likely a spark—ignited the flames, which rushed up the shaft. There was no exit at the forty-second floor, and

the men were trapped. The marble setters had already gone home for the day when the drywall crew heard screams coming from behind the wall.

The other workers made two attempts to rescue the men in the elevator shafts. The sledgehammers were two floors above, with no way to get to them. Nevertheless, one electrician—"a huge guy who we called Bear," Rowell recalls—managed to knock a hole in the drywall, only to find a rail blocking the way. A second attempt was similarly blocked by a ladder. By then, the screams had stopped.

Meanwhile, the First Battalion of the Chicago Fire Department was enjoying the spring weather with an outdoor barbecue at the station on Wells Street. A few of them glanced up, only to see the Sears Tower on fire! Engines arrived at the scene before anyone had a chance to call them, bewildering the rest of the construction crew until the four loudspeakers on every floor announced a warning for everyone to get out as fast as they could.

The charred remains of one of the victims were found on the forty-second-floor platform. The rest had jumped, their bodies later recovered from the elevator pit that stopped at the thirty-third floor. All had been burnt beyond recognition.[16] David Hoffman, who personally witnessed the incident, would say only, "It was horrible."

Hilda Wiggins's phone rang at 11:45 that morning. When she answered, the caller identified himself as a reporter and asked, "Is this the home of Robert Wiggins?"

"Why do you need to know?" Hilda asked, and hung up before the caller could answer. She tried to call Westinghouse, but no one knew anything and kept passing her higher up the ranks.

She went into the living room and turned on the television. As soon as she saw the fire trucks on the screen, she knew.

Work was stopped for the day, customary whenever a death occurred on-site. On the day William Walsh had planned to reunite his little family in their Melrose Park apartment, his widow, Jean, was instead telling a *Tribune* reporter about the Bronze Star and three Purple Hearts her late husband had earned in Vietnam. As the other three victims of the April 11 fire were laid to rest, the *Tribune* noted that Olson's services were "still pending."

"There was a huge attendance of elevator workers at Bob's visitation at the funeral home," remembers Hilda Wiggins, "and I can remember them

saying, 'I tried to pound the walls to get the guys, but it was impossible to do.' They were so broken up and sad." Now she and four-year-old Amy were left alone in the remodeled house. "It should never have happened in the first place."

THE FOLLOWING SATURDAY, AS usual, Jack DeKlerk was getting time and a half for working on the weekend. As he did every morning, he finished an early breakfast with his family and kissed his son goodbye. Little Jack, now twenty-one months old, was supposed to be asleep by the time his father returned from work, so mornings were their special time together.

Throughout the short, dark winter days, the view had been hidden by clouds. "In winter you couldn't see much," says Porzuczek, "but on clear days, it was beautiful." On that chilly spring afternoon, the city lay spread below John and Jack like Burnham's Plan of Chicago. They were sitting on a steel girder on the 109th floor, removing the metal chokers from the cables used to raise the beams.

"I was right next to him," Porzuczek recalls. "I was just focused on taking the cable apart." The heavy steel cables often frayed, leaving raised metal "burrs" that stick out like tiny spikes. One of these burrs must have caught on Jack's sleeve or glove, dragging him off the beam he was on. By the time someone screamed out, John looked down to see a crowd already gathered around his partner, who had fallen thirty-five feet onto the hard steel beams of the 106th floor below.

"When I got to him, they were already carrying him in the skipbox [a six-foot steel box used to remove construction waste], and lowered it over the side of building straight down to the street with him in it. The foreman radioed the office to get an ambulance. Jack wasn't in good shape…he was breathing, and then he stopped, and we knew he had passed away."

"NORTHWESTERN HOSPITAL CALLED, AND said there was an accident," remembers JoAnn DeKlerk. She called Jack's best friend, Babe, for a ride to the hospital, then called her in-laws, Betty and William. Then she waited, with the clock ticking agonizing minutes, for whoever would arrive first. When Jack's parents, Betty and William, brought her to the hospital, JoAnn ran inside and asked for news of Jack. The nurse only shook her head. Jo Ann turned and ran down the hallway, taking refuge in an empty room in the hope that the nightmare would go away.

But when she heard John Porzuczek carrying little Jack down the hall, she went out to take her son into her arms. She would have to be strong for him; from now on, it would be the two of them.

20

TOPPING OUT

A few days later, John Porzuczek, who prided himself on being "one of the first ones up [the structure] every morning," became the first man to reach the tower's full height of 1,450 feet. The construction phase of the Sears Tower—on time and 0.2 percent under budget—was almost complete.[47] All the steel beams were in place, except one. That one was painted white and sent to the Sears headquarters on Homan Avenue, where all the employees, from executives to mail clerks, signed their names on it. This beam symbolized the connection that each and every one of them would share with Sears, with the tower and with the city of Chicago, for as long as the building stands.

The "topping out"—the placing of the final beam—would be marked by a grand ceremony scheduled for May 3, 1973. All Sears employees, contractors and many city officials attended, including Mayor Richard J. Daley, "who was like God in Chicago," said Philip Chinn. "It was a very big ceremony because this was the largest building in the world, the mayor was very proud of it, Sears was very proud of it, and it was a big deal."

On that day, thousands of others involved in the Sears Tower project signed the last beam that Billy Stone's raising gang would lay in place. The Sears executives signed it; Bruce Graham and Fazlur Khan signed it; Richard Halpern signed it; my parents signed it; and Jack DeKlerk, Jo Ann and Bill signed it in the spot reserved for Mayor Daley. Then the mayor himself gave a speech: "Sears Roebuck, a name that means everything to the people of America, has no equal in the business world of Chicago."

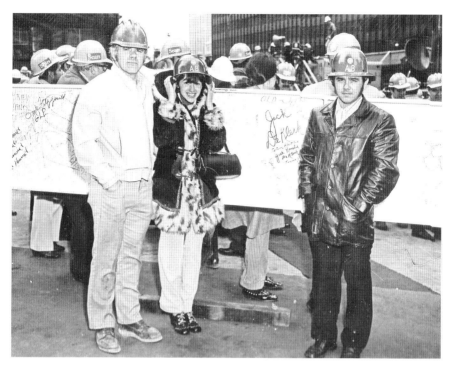

Ronnie Polk (*left*), Jo Ann DeKlerk (*center*) and Bill DeKlerk (*right*) at the Sears Tower topping-out ceremony, May 3, 1973. *Photo courtesy of Jo Ann DeKlerk.*

Howard Baxter, superintendent of American Bridge, tapped Richard "Dick" Gumber to man the crane that hoisted the final beam more than a thousand feet into the air.

In a scene reminiscent of setting the last timber of the Great Works almost seventy years earlier, "a chorus of hard-hat electrical workers calling themselves The Tower Bums" sang a song composed in honor of the occasion:

> *She Towers so high,*
> *Just scraping the sky—*
> *She's The Tallest Rock,*
> *Doo wop, doo wop, doo wop.*

No one was supposed to be permitted inside the structure, which was still a steel skeleton without walls or floors. That didn't stop Jo Ann's Uncle Ronnie from sneaking her and Bill up to the 109th floor while everyone

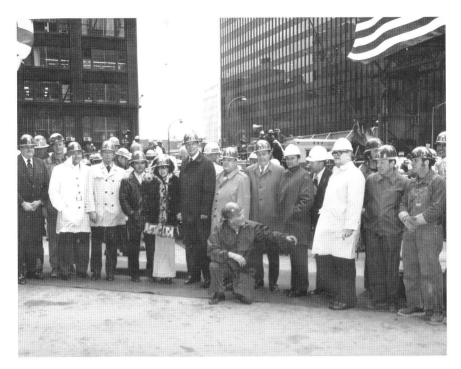

Even the executives from Sears and American Bridge caught the excitement. *Image courtesy of Jo Ann DeKlerk.*

below was occupied with the pomp and ceremony. Jo Ann wanted to see the place where Jack had fallen, and not even her fear would stop her. A few other workers joined the unauthorized adventure, riding first in one of the permanent elevators, then in the plywood construction elevator, which shook fiercely as it passed each floor. She marveled at the others casually chit-chatting as though this journey were perfectly normal.

Uncle Ronnie wouldn't let them go any farther; there were no walls up, and he feared the wind would blow Jo Ann right off the building. He continued to the 110th floor to take photos as John Porzuczek and Tommy Stack set the last beam. Jo Ann and Bill walked carefully among the cables and barriers. "We were afraid to move," she remembers. But she'd come this far and wasn't turning back now.

Near the spot where her husband had fallen to his death, Jo Ann placed one foot on a steel beam. "My foot was a little wider than it was," she says. "Those guys walk those beams all the time."

Would she do that again? "Absolutely not. It was one of the scariest things I have ever done."

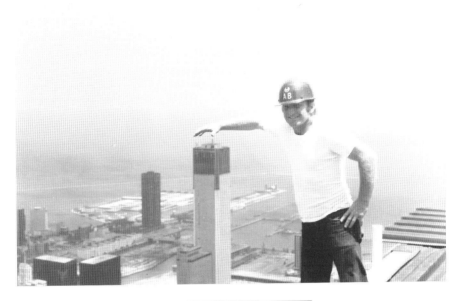

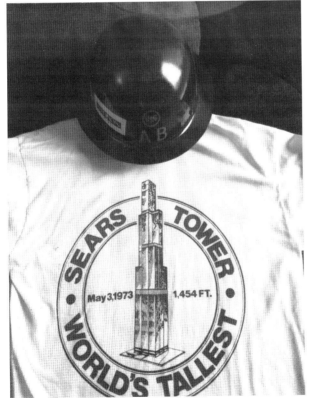

Above: Crane operator Dick Gumber has a little fun with perspective. *Photo credit: Richard Gumber and Scott Rowell.*

Left: Commemorative Sears Tower T-shirt designed by Scott Rowell. *Photo credit: Scott Rowell.*

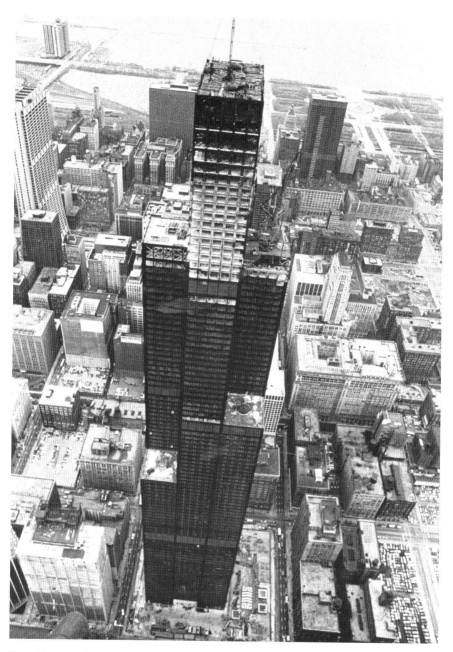

Sears Tower under construction. *Photo credit: Jo Ann DeKlerk / American Bridge.*

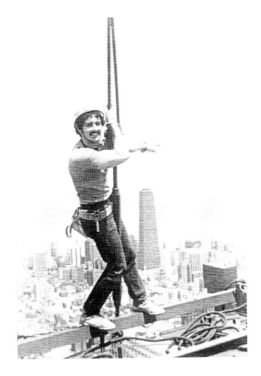

Scott Rowell surveys the city. *Photo credit: Richard Gumber and Scott Rowell.*

On the ground, Mayor Daley was invoking Chicago's patron saint of planning, Daniel Burnham: "Make no little plans," he told the shivering crowd. "They have no magic to stir men's blood."

There were cheers and applause as word came that the last beam was in place. Final words were said and thanks given, then the crowd dispersed—and just a few hours later, in true Chicago fashion, there was a drunken brawl among more than one hundred ironworkers and members of the other trade unions. It began with a dispute over the rights to a keg of beer and ended with forty police officers called to the scene at Franklin Street. John Porzuczek recalls that the Chicago police swiftly defused the situation, eager to avoid marring the big day with negative publicity. And did he himself play any part in the conflict? "No," he says quickly, but as the memories of forty-five years come back: "Well, um…yeah, probably."

The *Chicago Daily News* reported a disgruntled Morse-Diesel executive standing off to one side, shaking his head. "It's the shortest topping-out party and the shortest fight I've seen in awhile."[48]

21

MOVING UP

The Sears Tower had taken three and a half years to complete, from breaking ground to moving in. "In today's world," observes David Crowell, "that's remarkably fast." Move-in began in September 1974. Eight thousand Sears employees now occupied the tower's first fifty floors. A robotic mail delivery system replaced mailroom workers. The new configuration, scientifically designed to be the most efficient workplace ever, was bewildering and frustrating at first. Because of the fifty-thousand-square-foot space, a lot of people ended up with windowless offices. There were sixteen thousand windows in the Sears Tower, but not everybody got to have a view.

The last time Sears had moved its headquarters, more than six decades before, horse-drawn wagons had carried loads of office equipment and paper files from Fulton Street to the Great Works on Homan Avenue. Now it took three moving companies to pack, label, transport, deliver and unpack the countless cartons destined for the Sears Tower, all labeled and color-coded by department, floor and room. Sears's top officials were on hand to congratulate employees on "landing" at the new offices. Each employee had a new nameplate, and every female employee received a red rose on her desk. Downstairs in the lobby, the "usherettes" were busy frantically flipping through the Sears Tower directory, trying to figure out where to direct the deliveries that kept pouring in. "They keep sending flowers," one exhausted woman said, "and we can't find where the people are."[49]

Ironically, the consolidation of physical space served to widen the distance between employees. Neither Sears nor Environetics had considered the effects that the shift from the sprawling complex of the Great Works to a vertical skyscraper would have on the friendships that had developed over the decades at Sears. The tower's configuration made it impossible to simply drop by someone's office anymore; locating someone became an odyssey one had to commit to. New social circles were defined by who shared your elevator bank, and old ones faded away.

It might have been a portent of things to come.

REGARDLESS OF WHO OWNS it or what name it's given, the Sears Tower itself remains an indelible part of Chicago's architectural, cultural and artistic fabric. Like many iconic landmarks, it has characters and stories of its own.

CALDER'S *THE UNIVERSE*

Richard Tomlinson stresses that the artwork in the Sears Tower lobby was conceived as part of the project, not simply a decorative add-on. Before the design or sculptor had even been selected, the *Tribune* reported that the planned artwork would be "several stories high, and modern."[50] In September 1973, Alexander Calder, "the father of kinetic art," was selected to design a "great mobile" that would hang from the ceiling and jut out from the marble wall of the lobby itself. Calder visited the lobby of the Sears Tower, stared for a few minutes at the marble wall, then took pen and paper from his shirt pocket and began to sketch. When asked by a reporter what he saw, Calder replied, "I see colored objects, moving. I'm gonna work with it."[51]

The Universe was unveiled on October 25, 1974, along with Calder's *Flamingo* sculpture in Federal Plaza. Preservation Chicago described *The Universe* as "a monumental, colorful, kinetic, motorized, playful mobile that depicts an abstract version of the celestial bodies including the sun, moon and starts...a delightfully whimsical visual counterpoint to the serious, monochromatic, and highly geometric Sears Tower."[52] Chicago hosted a parade in the sculptor's honor, "which featured more than a dozen circus wagons, clowns, unicyclists and multiple marching bands. Calder was introduced by Chicago architect Carter Manny as 'the one and only Alexander the Great.'"[53] The Museum of Contemporary Art also opened *Alexander Calder: A Retrospective Exhibition*.

MAYOR OF THE SEARS TOWER

Thank God for Leroy Brown," said Philip Chinn, the Sears Tower's general manager.[54] Brown, the man in charge of the tower's security for thirty-three years, might have relied solely on his physical presence to deter shenanigans. At six feet, five inches tall, the former Green Beret was a commanding presence. But what struck people most about Brown was his sharp mind, calm authority and friendly demeanor, which heightened the sense of community and safety among those who worked in the Sears Tower.

Part of Brown's job was to keep an eye on the 25,000 visitors who flooded the Sears Tower each day. At various times, he had also tackled a fleeing robber, helped coordinate the evacuation of all 110 floors of the tower after the 9/11 attacks in New York and survived a bomb attack carried out by a radical nationalist group in 2005. At the moment the blast blew out sixty windows in the building, Brown was safe behind a cement pillar, answering an unexpected early-morning phone call from his wife, Patricia, who'd had a feeling something was wrong. "Now," he said after the bombing, "I always take her calls."

YOUR FRIENDLY
NEIGHBORHOOD SPIDER-DAN

When I scaled the Sears Tower in Chicago in 1981," says climber Dan Goodwin, "I just had…a pair of suction cups and skyhooks." Dressed as the famed Marvel character Spider-Man, Goodwin launched his career as a daredevil climber on Memorial Day, May 25. "Some of the macho younger members of the security staff wanted to block him with the window-washing equipment and then remove a window and grab him," Philip Chinn recalled. "Luckily, Leroy [Brown] prevented such antics." Brown later kept Goodwin's suction cups as souvenirs.

Most of the city cheered Goodwin's progress as he neared the 110th floor. "When I got to the top, the policemen were throwing me up in the air," said Goodwin. "They loved it." Then they arrested him for disorderly conduct, but thanks to Sears, he was released with a fine of thirty-five dollars. The Chicago press corps christened him "Spider-Dan," a name that stuck through his subsequent climbs of the John Hancock Center and other skyscrapers around the globe.

"It is evident," Sears spokesman Ernest Arms told reporters, "that Dan Goodwin has captured the imagination of the public as well as Sears."[55]

"ANYTHING IS PEACEFUL FROM 1,353 FEET"

I t's always a good day to visit the Sears Tower. In the sixty seconds it takes to ride to the observation deck, the pressure behind your eyes changes, and your heart lurches just a bit as the doors slide open at the 103rd floor. On clear days, you can gaze out over Wisconsin, Illinois, Indiana and even Michigan, just barely visible where the lake meets the horizon. On cloudy, windy days, you can't see anything, but you can feel the building sway ever gently beneath your feet, sometimes as much as four inches. Others may get nervous, but you, having read this book, will rest securely in the knowledge that Bruce Graham and Fazlur Khan knew what they were doing. Maybe you'll treat yourself to one of the countless souvenir reproductions of the Chicago skyline's most iconic building in the form of keychains, mugs, pencil sharpeners, coin banks, puzzles, postcards and paperweights. And maybe, like Ferris Bueller, you will be inspired to pause for a moment and reflect.

I think of many things whenever I visit the 103rd floor of 233 South Wacker: memories of visiting here with my parents, or on school trips, or on days I was supposed to be in school (ahem), or of the wonder on my daughter's face the first time she saw the tiny cars crawling like ants along the ribbons of pavement below. I marvel at the building's sheer magnificence as an epic monument of design and labor, a literal representation of the role a store once played in this city. I reflect on how the Sears Tower and I are almost exactly the same age; I like knowing it will be around long after I'm gone.

A resolution

adopted by The City Council
of the City of Chicago, Illinois

Presented by <u>Alderman Leon M. Despres</u> on <u>July 25th, 1973</u>

Whereas, *Chicago's great buildings have been made possible only by the willingness of Chicago construction workers to risk injury and even death in the performance of their work. For example in the construction of the spectacular new Sears Tower, four elevator workers, a steel worker, and an architectural iron worker have been killed during construction work.*

THEREFORE BE IT RESOLVED BY THE CITY COUNCIL OF THE CITY OF CHICAGO:

The City Council expresses appreciation to all construction workers for the risks they take and expresses special appreciation and sympathy to the families of the six men who were killed in construction of Sears Tower:

JACK DE KLERK -- *WALTER KETTLESON* -- *LARRY LUCAS*
LEONARD OLSON -- *WILLIAM WALSH* -- *ROBERT WIGGINS*

MAYOR CITY CLERK

City of Chicago resolution honoring construction workers. *Image courtesy of Hilda Wiggins.*

But now I also think of the six men who gave their lives to build it, and I remember their names: Jack DeKlerk. Walter Kettleston Larry Lucas. Leonard Olson. William Walsh. Robert Wiggins. This chapter is dedicated to them.

EVERYTHING MUST GO

S o, what went wrong?

How did the World's Largest Store go from dominating the retail industry in the mid-1970s to being ranked "worst stock in the world" in 2016?[56] The suddenness and speed with which the once mighty retailer began to decline was like a fall from a dizzying height, the ground rushing up to meet you before you had completely processed what was happening. So, if it seems strange and sudden to go from reading about Sears's most towering achievement (pun intended) to reading about its long, slow collapse, imagine what it was like to actually live it.

The first signs of trouble came just a few months after move-in at the new Sears Tower headquarters was complete. The postwar economic boom couldn't last forever; its ripple effect had been slowing and hit a period of "stagflation" from November 1973 to March 1975, during which wages remained the same but prices rose sharply. Still, Sears weathered that storm better than most, even adding at least fourteen retail stores nationally.[57] The thousands of Chicago-area Sears employees weren't too worried; after all, everyone knew the world's largest retailer was unsinkable.

Epics have been written about empires that rose and fell not because of barbarians at their gates, nor even due to enemies from within. Some empires simply decay over time, dying not from a single fatal wound but from a thousand cuts. No two theories about the demise of Sears are the same, but many of the same culprits crop up in different versions: overconsolidation of management in some areas, redundant layers of management in others;

failure to anticipate the threat from competitors; accruing $2.1 billion in long-term debt and more than $700 million in pension liabilities; an 85 percent plunge in stock price. Perhaps worst of all, Sears's brand perception took a major hit when it tried, against all precedent and logic, to cut its way to prosperity.

"It was like everyone was asleep at the switch," recalls my father. Sears had grown so enormous, so complacent in its own prosperity that it assumed it could continue doing things the same way it had always done them. Ryan Julian shares a similar sentiment, blaming Sears's slowness to keep up with changes in the market or respond proactively to competitors like Target and Walmart. "Once you stop innovating," he says, shaking his head as we stand in Chicago's last remaining Sears store in Chicago on its final day, "that's it."

Ironically, Robert Wood—the most innovative Sears executive since Richard Sears himself—did not encourage innovation or risk-taking among his junior management. "General Wood placed a high value on harmony within the Sears office group," explained Sears historian James C. Worthy. "Sears would be all right, [Wood] frequently adjured them, as long as its officers worked together as a team and no divisiveness or factionalism developed among them."

As EFFECTIVE AS WOOD'S militaristic management style was, it regarded any type of deviation from its established business practices as a threat. According to Kate Fitzgerald, he "demanded that rising young executives relocate to new stores approximately every 18 months as the retail network grew and grew. It was a grueling path for many, but the process guaranteed Sears' managers were well-trained and every store was squeezed to produce maximum results." However, this practice also ensured that "at Wood's retirement, there were very few people in executive positions who had ever worked anywhere but Sears."[58] The general's looming presence on the board for more than a decade after his formal retirement in 1954 "was a further inhibiting influence" on the company's growth. Whatever the reasons, Sears wasn't keeping up the rate of growth it had counted back when Environetics was analyzing space needed in the Sears Tower. By the 1980s, it was clear the company was struggling to stay on top, and it began selling off its assets.

The first major blow to the city itself came in November 1988, when Sears, "whose name has been synonymous with Chicago for more than a century," announced it was putting its namesake tower on the auction block and moving out. The company had occupied its record-breaking

headquarters for barely half of its planned three-decade stay. The move left 1.8 million square feet of office space unoccupied—equivalent to fifty stories. Maybe Sears had been serious about moving to Texas, or maybe this was simply a clever negotiation tactic to get $61 million in Illinois tax incentive, which Governor James R. Thompson called "the largest retention offer ever put forward by the state."

Sears CEO Edward Brennan, who himself had "strong suburban ties," claimed the move was the most difficult decision he had ever faced. The $178 million in tax exemptions offered by suburban Hoffman Estates probably didn't hurt, either. But, he assured a nervous city, "We will take the entire merchandise group" to Sears's sixth headquarters.

PRAIRIE STONE

The two-hundred-acre complex, called Prairie Stone, would be built on almost eight hundred acres of sweeping farmland. Once again, Sears calculated the space it would need over the next thirty years, with plans to lease extra space to service providers and other tenants. Once again, the plan was to build "a city unto itself, [with] its own fire station, switching facility and Northern Illinois University education center.…[P]lans call for a hotel, bank, day-care center and health club." The idea was that, just as Sears stores anchored nearly every shopping mall in America, Prairie Stone would be home to major office buildings, research and development facilities, utilities companies and retail and restaurant space, with Sears as "the owner and anchor of the park."[59]

Richard Halpern, who had left Morse-Diesel in 1975 to form Schal Associates, once again oversaw the construction of the new Sears headquarters. Groundbreaking began in August 1990. Brennan refused to project how many of the six thousand in the Chicago merchandise division would survive the "organizational adjustments."[60] But between vacating the Sears Tower in 1989 and the scheduled opening of the Prairie Stone complex in 1992, there was an enormous logistical problem: where would those employees work in the meantime?

The answer soon became clear: many of them simply wouldn't. The downsizing was swift and terrible, destroying what little remained of company morale and throwing thousands of lives into turmoil. Despite heavy losses, my father hung on through each round of purges, transferring first to

Sears offices in Skokie, then Northbrook, then back to Skokie. Each location followed the same dismal pattern: people came to work in the morning as usual and were cleaning out their desks by afternoon. After six months, the decimated office consolidated its remaining employees and transferred them again. Each time, the odds got slimmer. But there was hope to hold on to: there would be room for the merchandising group at Prairie Stone, as Brennan had promised. After all, Chicago would always need Sears, and Sears would always need a catalog—wouldn't it?

The move to the new headquarters also involved a purge of most (if not all) of Sears's records, without any consideration at all for future researchers. Some employees found this unsettling; was it an indication of the true direction the catalog division was heading in? Certainly the higher-ups had to know what was coming, and letting word get out before it was unavoidable would only speed things from bad to worse.

"We thought we were going to Prairie Stone," my dad says. "We didn't know we were going into oblivion."

THE BOOK CLOSES

January 1993 marked the beginning of Sears, Roebuck & Company's centennial year. Walmart had knocked Sears off its "world's largest retailer" throne two years earlier, and its market share was now in third place, behind the once-disdained Kmart. With twenty straight years of losses of as much as $175 million in a single year, it was time to take a long, hard look at Sears's time-honored mail-order practice. Was Sears's slowness to add a 1-800 ordering number to its Big Book part of the problem? Or was it the staunch refusal to even consider accepting Visa and Mastercard payments (rather than the Sears-owned Discover card) until the catalog was on the brink of death? It certainly couldn't be due to poor management decisions, like requiring customers to get in their cars and drive to a merchandise pickup counter at a Sears store instead of mailing orders directly to the customer's home, the way pretty much every single other retail store did by then.

No, Sears's CEO, Arturo "Arthur" Martinez, decided on the eve of Internet retail that *people just didn't like to shop by mail anymore*. Referring to the catalog as an "unprofitable business" (how Richard Sears must have scratched at his marble tomb when he heard that!), Martinez boasted of his future fame as "the guy who got Sears back on its feet."[61] He did it by firing my dad, along with fifty thousand other Sears Catalog employees across America—eighteen hundred of them in the Chicago area alone.

And so, instead of nurturing the golden goose that had given it so many precious eggs, Sears chose instead to slaughter it.

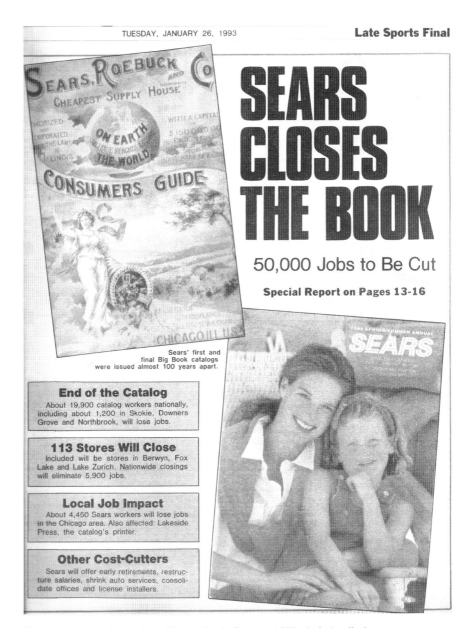

Late Sports Final

SEARS CLOSES THE BOOK

50,000 Jobs to Be Cut

Special Report on Pages 13-16

Sears' first and final Big Book catalogs were issued almost 100 years apart.

End of the Catalog
About 19,900 catalog workers nationally, including about 1,200 in Skokie, Downers Grove and Northbrook, will lose jobs.

113 Stores Will Close
Included will be stores in Berwyn, Fox Lake and Lake Zurich. Nationwide closings will eliminate 5,900 jobs.

Local Job Impact
About 4,450 Sears workers will lose jobs in the Chicago area. Also affected: Lakeside Press, the catalog's printer.

Other Cost-Cutters
Sears will offer early retirements, restructure salaries, shrink auto services, consolidate offices and license installers.

Sears announced the closing of its catalog in January 1993. *Author's collection.*

The morning headlines of the *Chicago Sun-Times* blared the news that General Robert Wood, Julius Rosenwald and Richard Sears could never have imagined: the former World's Largest Store was closing its catalog, shuttering hundreds of retail stores and cutting fifty thousand jobs nationwide. My father still has these and other newspapers from the time, slid carefully into plastic document sleeves. By that time, he'd been a buyer for the Sears Catalog for half his life, and though he never worried in front of us, I knew it was bad when I saw he'd saved the newspapers. I was in the middle of my second year of college. What would happen now? And all over the city, versions of our small drama were being played out in the homes of managers, retail employees, photographers, catalog set designers and countless people all the way down the supply chain.

Workers in the Chicago area were hardest hit. Sears shuttered "unprofitable and poorly located" stores in Berwyn, Lake Zurich and Fox Lake. In Skokie, Downers Grove and Northbrook, 1,200 catalog employees found themselves shown the door, along with another 600 from the catalog's printer, R.R. Donnelley & Sons. That month, Donnelley announced it was shutting down its Lakeside Press imprint, which had published the Big Book since 1928, and "very likely" eliminating 660 jobs. Despite posting record earnings the previous year, Lakeside literally couldn't afford to lose its biggest customer, which had provided more than half its business.[62]

"I worked for Sears just as much as anybody else who ever worked for them," said Norm Christensen, a printer in the catalog division of Donnelley since 1957. "Thirty-five years of printing their catalog, and I get this."

It would have been cold comfort to know that Sears was treating its own no better. The waves of shock, indignation, pain, anger, worry and betrayal were heightened by the rigidly by-the-book treatment of its loyal workforce—regardless of whether it made sense. The company determined its soon-to-be-involuntary-retirees' eligibility for retirement strictly by age, not by years of service. This had always been the policy at both Sears and Donnelley (both of which had successfully kept unions at bay in a staunchly union town), but now it added an especially bitter sting to the blow of separation.

Sears, once the great adapter, continued to flounder into the early twenty-first century behind competitors it had once left in the dust. The company offered early retirements, cut salaries, automated many of its ordering and delivery services, consolidated offices and turned to outside contractors to install Sears appliances. Nothing worked. Any company might suffer during a recession, even one as mammoth as Sears, but stronger management

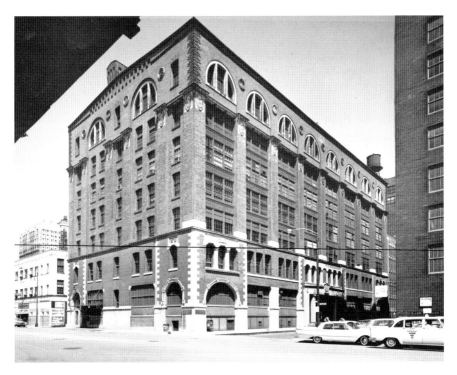

The Lakeside Press Building, 731 South Plymouth. R.R. Donnelley built this 45,000-square-foot facility in 1948 to print seven million copies of the Sears catalog annually. *Library of Congress.*

might have weathered the storm better. General Robert Wood's strategy in the Depression had been to open more retail stores. After World War II, as Montgomery Ward and other competitors cautiously conserved their inventory, Wood called for more inventory, more stores, more more more. Now Sears did the opposite: cutting inventory, consolidating management, selling off assets. By 2016, Sears Holdings had fallen to twentieth place in the National Retail Federation rankings, behind Publix Super Markets, Rite-Aid and Aldi.[63]

"It's so hard to see such a great institution just fade away," Dennis Mele says mournfully. Of all the emotions stirred up by memories of those five tenuous years of worry and hope and more worry, what my parents now remember most is the sense of sadness. Chicagoans grieved the loss of what Sears once was and still grieve for what it might have been:

> *For most corporations, it's one great idea and out....Sears had two, and could have had more, if their institutional memory had endured rather than simply been discarded. Instead of creating Amazon.com...Jeff Bezos*

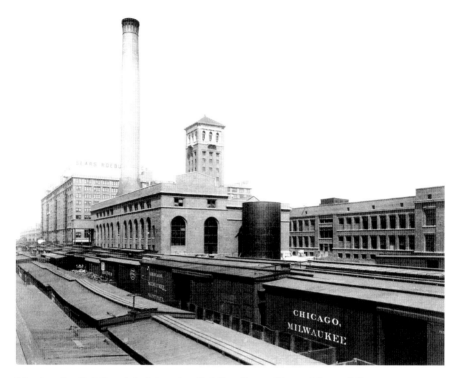

Merchandise Building, Administration Building, Power House. *Library of Congress.*

might have followed Sears, Rosenwald and Wood in the line of great Sears Roebuck presidents, and Chicago would have been at the center of it, rather than shuffled off to the sidelines. The great Merchandise Building, already paid for, would have found new life as a booming, integral piece in the new hyper-efficient supply chain.[64]

The sun has now set on the Sears empire in Chicago, and the rest of the country may soon see the disappearance of what was once the world's largest and most respected retailer. Sears Holdings Inc. continues to limp along, shorn of most of its holdings, but its days are numbered. No company can survive such massive cuts and layoffs and divestments and nine-digit losses year after year—and yet Sears still somehow just barely hangs on. It's a testament to the size and strength Sears once enjoyed that it has taken this long to die from a thousand cuts.

With some notable exceptions, many of the visible reminders of Sears's 125-year presence in Chicago have fallen into decay or disappeared entirely.

WHERE ARE THEY NOW?

THE CHICAGO SEARS STORES

- Original Sears retail store, located in the Merchandise Building of the Great Works (Lawndale neighborhood), demolished 1995
- Lawrence Avenue (Ravenswood neighborhood), closed August 2016
- Seventy-Ninth Street (Avalon Park neighborhood), closed July 2013
- Western Avenue (Chicago Lawn neighborhood), closed July 2013
- State Street (Loop), closed April 2014; now Robert Morris College
- Sixty-Third Street (Englewood neighborhood), demolished 1974
- North and Harlem (Galewood neighborhood/Elmwood Park), closed September 2017
- Six Corners (Irving Park neighborhood), closed July 2018

THE GREAT WORKS

Declared a National Historic Landmark in 1978, the Great Works continued to handle mail orders until 1987. Even then, Sears felt a sense of obligation to the North Lawndale neighborhood it was leaving after nearly one hundred years as an anchor. In 1989, Sears chairman Ed Brennan and retired vice-president Charlie Moran partnered with

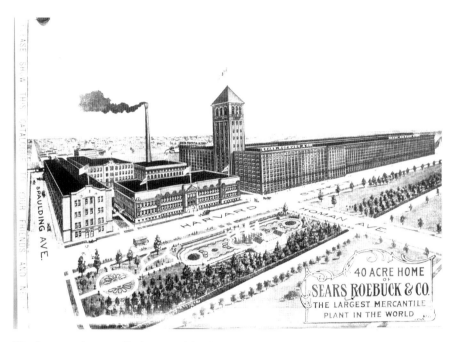

The Sears catalog proudly showcased the Great Works as a tourist attraction. *Library of Congress.*

developer Charles H. Shaw to form the Homan Arthington Foundation, later the Foundation for Homan Square, a 501(c)(3) intended to redevelop the complex into "affordable, mixed-income, for-sale and rental housing, community services, and education facilities." The project received enthusiastic support from business and community leaders, and Mayor Richard M. Daley pledged city funding to improve roads, sewers and other infrastructure.

However, the project stalled after Sears sold the complex to the Royal Imperial Group in 2004, but it was restarted three years later by Mercy Housing Lakefront, a nonprofit organization whose mission is "revitalizing neighborhoods." Improvements included a $40 million overhaul to transform the old powerhouse into the Henry Ford Academy Power House Charter High School in 2009 and redeveloping 181 units of affordable housing in the former Printing Building in 2015. The fourteen-story original tower has been rechristened Nichols Tower, "a hub for arts and multi-media education, youth leadership development, job training, and urban farming."

Seventh floor of the Merchandise Building. *Library of Congress.*

The Allstate Building. *Photo credit: Martin Gonzalez.*

Interior of Allstate Building, 2007. *Photo credit: Martin Gonzalez.*

Third-floor interior courtyard wall, shelving and conveyors. *Library of Congress.*

Inside the Allstate Building. *Photo credit: Martin Gonzalez.*

Chicago architecture blogger Lynn Becker pays the former headquarters an almost Shakespearean tribute:

> *The massive complex Sears built around Homan and Arthington in the first decade of the 20th Century was an explosive punctuation point in the timeline of the Age of the Supply Chain. Its sheer scale and volcanic energy was as destructive and transformative as a meteor reshaping a terrain as it slams into the earth. Today, that once decisive moment is long dispersed, implied by the void where the massive two-block long Merchandise Building once stood, its small, tall tower still standing in surreal isolation, looking almost like a toy. Some surviving buildings have been repurposed. Others, abandoned and rotting, are like deposed monarchs who have lost their kingdom and now walk the streets seeking alms.*

The Homan Square complex has also served as a filming location for *Ocean's Twelve* (2004) and *Stranger than Fiction* (2006). Photographer Martin Gonzalez documented some haunting images of the buildings before the developers arrived in 2007, showing furniture and equipment frozen in time like the ruins of a once-great civilization.

THE SEARS TOWER

Since its most recent acquisition by the Blackstone Group in 2015, the tower has renovated its 103rd floor observation deck, now called Skydeck Chicago. Its newest attraction is The Ledge, a clear viewing box that extends more than four feet from the building's face and provides intrepid visitors a sweeping panorama of the city below. Only a half inch of laminated glass separates you from the quarter mile of empty air beneath you.

When Blackstone purchased the Sears Tower in 2015, Calder's *The Universe* was not included in the sale. It was dismantled and placed in storage amid a fierce legal battle over its ownership that has yet to be resolved.

The city and the Sears Tower. *Photo credit: Martin Gonzalez.*

WLS RADIO

Even after Sears sold WLS to *Prairie Farmer* magazine in 1928, the *National Barn Dance* remained on the airwaves for another forty years. Its legacy is the Grand Ole Opry, as well as Chicago's WLS television affiliate, ABC 7 Eyewitness News. Today, WLS radio is a subsidiary of Cumulus Media, broadcasting out of Tinley Park, Illinois.

PRAIRIE STONE

And what of Sears's grand experiment in Hoffman Estates? "It didn't work," Mayor William McLeod told the *Daily Herald* in 2011. Nearly twenty years after building Prairie Stone, Sears still hadn't recouped the $125 million it had put into developing the park—which then asked the village of Hoffman Estates to reimburse. After the company once again threatened to move out of state, Hoffman Estates voted in 2012 to extend the incentives package it had granted back in those heady days of wooing

Sears. This time, however, the agreement came "in exchange for…a commitment," as real estate vice-president Jim Terrell put it.[65] Sears would stay…but for how long?

Ironically, Prairie Stone's location "may have hampered development," since property taxes are much lower in Kane County, only a mile and a half away. The village spent "hundreds of thousands of dollars in recent years trying to attract companies," to little avail. In 2018, Sears laid off more than 400 employees at its Hoffman Estates headquarters. While the company still provides approximately 15,000 jobs in Illinois, it will not disclose how many employees remain at Prairie Stone. This is likely because Sears will lose its state tax incentives if it employs fewer than 4,250 people at its headquarters and lone remaining satellite office in the Loop at One North State Street. Given this dismal prognosis, it seems increasingly likely that Sears's current headquarters will also be its last.

LIFE AFTER SEARS

And what about us? We, the people who were part of the Sears family? We, the city of Chicago? "In the long run, this city will survive," Mayor Richard M. Daley had told *Tribune* reporters when Sears left its tower headquarters in 1988. And we did.

The last evening my father ever came home from work after twenty-four and a half years at Sears, there was a sense of relief that at least the uncertainty was over. Thankfully, he lasted long enough to qualify for his full pension at age fifty. He was luckier than his coworker, who'd been hired at Sears right out of high school at age eighteen and, thirty years later—still two years shy of pension age—got nothing.

Dennis Mele, who survived the catalog shutdown because of his retail background, became a casualty of the merger with Kmart in 2005 (during which the company's name was officially registered as Sears Holdings Inc.). After a lifetime of service, the separation was sudden and painful. "The day I was told there was no job for me anymore, after thirty-four years, was one of the most traumatic days of my life."

And yet there *was* life after Sears. Time heals many wounds and allows space to reflect. "I started my professional career at Sears, and it became a large part of my identity," says Dennis Mele. "Sears and I were part of the same whole. When I left, I saw that it was a mistake to let that happen."

Ninety-eight-year-old Bob Judd, now without any Sears profits to share in his golden years, plans to write his memoirs. Certainly they are needed as an invaluable record of the remarkable century-long run Sears had as the retail

Three generations of a Sears family at the tower observation deck, 103rd floor, 2018. *Author's collection.*

king of the city and the nation. "We were like men on the moon," my mom says, her voice still carrying a trace of pride, despite everything. "We did it first; we did it best."

Amy Wiggins, who was four years old when her father, Robert, died in that terrible accident in the Sears Tower elevator shaft, knows how much her dad loved his work. She reminds her mother, Hilda, how proud he was—and would be today—to be part of one of the greatest engineering feats of the twentieth century. John Porzuczek told me of meeting up several years ago with "little Jack," by then in his thirties, to give him a jacket emblazoned with "Ironworkers Local #1—Chicago, Illinois." I thought of them, and of many, many others, many times as I tried to write the ending to this book. How do you celebrate a legacy—of a man, a business, a city—while grieving a loss that should never have happened in the first place?

"It all worked out," my mom says. But then, that's what she always says. She's usually right; it did work out for us, and for thousands of others who found their way to new shores. My dad retired from his second career in 2008 and now spends his days happily occupied with his books, movies and granddaughters. We continue the family tradition of taking them to the Sears Tower; some things are still sacred. We're still going strong, even if Sears isn't.

During the clearance sale at the last Sears store in Chicago, I bought my daughter a pair of emerald earrings, her birthstone. She's still too young for them, but someday I will give them to her and tell her about everything Sears gave to our family and to the city we love, and the legacy it left us.

I told Dennis Mele of my frustration at being unable to give the story of Sears in Chicago a happy ending. His reply is worth sharing here:

View of Chicago from the Allstate Building. *Photo credit: Martin Gonzalez.*

> *Maybe the high note of your story can be that everyone eventually survived the fall of the great Sears empire. People should know that the human spirit can overcome great loss. The things we all learned from those early years in the Sears family served us well in life after Sears. We can all be proud that we were once part of something great.*

I couldn't have said it better, Dennis. Thank you.

NOTES

Introduction

1. Sears Archives, "Irving Park Store."
2. Sears advertising slogan from 2001–2.
3. Nickerson, "When Sears."
4. Rivera, "Final Chicago Sears."

Chapter 1

5. *Mr. Sears Catalog.*
6. *Kiplinger's Personal Finance.*
7. Ibid., 5.

Chapter 2

8. Sears Archives, "Julius Rosenwald."
9. Ascoli, *Julius Rosenwald.*

Chapter 3

10. At the time of this meeting, Loeb's wife was pregnant with their third son, Richard, who would one day become infamous as one half of the "Leopold and Loeb" killers. On May 21, 1924, Loeb and his friend Nathan Leopold murdered fourteen-year-old Robert Franks, who was Loeb's second cousin and the son of a prominent Chicago watch manufacturer. Albert Loeb's position at Sears prevented him from retaining the law firm of Lederer and Lederer to defend

his son, since the company was also a client. In the end, Clarence Darrow's impassioned twelve-hour plea saved Leopold and Loeb from death. Albert Loeb died of a heart attack six weeks after his son was sentenced to life plus ninety-nine years.

11. Horowitz, *The Towers of New York*.
12. Mooney, "Sears Roebuck and Co."
13. Becker, "The Architecture of the Age."
14. Horowitz, *The Towers of New York*, 70.

Chapter 5

15. Thornton, *Houses that Sears Built*, 10.
16. There was (and still is) a popular brand of prefab homes called Craftsman, which has caused much confusion among kit home owners and hobbyists alike. Despite sharing a name with the brand of tools Sears sold, Craftsman homes are *not* Sears homes; the only brand of kit homes Sears ever sold was Honor-Bilt, although other retailers sold this line as well.
17. Stevenson and Jandl, *Houses by Mail*, 20.
18. Solonickne, "Sears Homes of Chicagoland."
19. Stevenson and Jandl, *Houses by Mail*, 19.
20. Thornton, *Houses that Sears Built*, 13.
21. Mooney, "Sears Roebuck and Co."
22. *Would You Buy a Home from Sears?*
23. Thornton, *Houses that Sears Built*, 68.

Chapter 6

24. Ascoli, *Julius Rosenwald*, 229–30.
25. Illinois Business Hall of Fame, "Robert Wood," 178.

Chapter 7

26. "Population History of Chicago."
27. Ibid.
28. Emmet and Jeuck, *Catalogues and Counters*, 341.
29. Ascoli, *Julius Rosenwald*, 227.

Chapter 8

30. Encyclopedia of Chicago, "Century of Progress Exhibition."
31. "Sears Roebuck & Co. at the Century of Progress." Author's collection.

Chapter 10

32. Fitzgerald, "Sears, Ward's."
33. Ibid.
34. Becker, "Architecture of the Age."
35. Sears Archives, "Craftsman."
36. Illinois Business Hall of Fame, "Robert Wood."

Chapter 11

37. "When Sears Shared."

Chapter 12

38. Enstad, "Girder Tops Sears 'Rock.'"

Chapter 13

39. Marx, "Sears Tower."
40. Schmich, "MLK's Legacy."

Chapter 14

41. D'Eramo, *Pig and the Skycraper*.
42. Greene, "Man Who Saved the Skycraper."
43. Nagelberg, "Sears Tower."

Chapter 15

44. *Chicago Tribune*, August 30, 1970.

Chapter 19

45. Enstad and Haramija, "Sears Tower Blaze."
46. Ibid.

Chapter 20

47. Brashler, "Empire Scales Back."
48. Shaffer, "Hardhats Climax."

Chapter 21

49. Collin, "Pioneers Land at Sears Tower."

Chapter 22

50. *Chicago Tribune*, September 8, 1973.
51. Reich, "Calder Views the Challenge."
52. Preservation Chicago, "Calder's The Universe."
53. Kamin, "Calder's 'Universe.'"

Chapter 23

54. *Chicago Tribune*.

Chapter 24

55. Skyscraperdefense, "Skyscraperman."

Chapter 26

56. Sozzi, "20 Reasons."
57. Encyclopedia of Chicago, "Sears, Roebuck & Co."
58. Worthy, *Shaping an American Institution*.

Chapter 27

59. Christian, "Sears Drawing."
60. Green and Shryer, "Sears to Move."

Chapter 28

61. Strom, "Sears Eliminating."
62. Maclean and Coates, "Sears' Bells Tolling."
63. "Stores Top Retailers 2016," National Retail Federation.
64. Becker, "Architecture of the Age."

Chapter 29

65. Harris and Hinkel, "What Went Wrong."

BIBLIOGRAPHY

Ascoli, Peter M. *Julius Rosenwald: The Man Who Built Sears, Roebuck and Advanced the Cause of Black Education in the American South.* Bloomington: Indiana University Press, 2006.

Becker, Lynn. "The Architecture of the Age of the Supply Chain: The Epic Saga of Sears in Chicago." Creation and the Politics of Gender: Modernism's Messengers—The Art of Alfonso and Margaret Iannelli. January 1, 1970. Accessed June 1, 2018. http://arcchicago.blogspot.com/2013/03/sears-in-chicago-at-discard-end-of-age.html.

Brashler, Bill. "An Empire Scales Back." *Chicago Tribune* (online), April 30, 1989. Accessed June 1, 2018. http://articles.chicagotribune.com/1989-04-30/features/8904080425_1_sears-employees-gordon-metcalf-walk/2.

"Calder's The Universe Sculpture at Willis Tower Disassembled with Future Unknown." Preservation Chicago. Accessed June 1, 2018. https://preservationchicago.org/newsletter_posts/calders-the-universe-sculpture-at-willis-tower-disassembled-with-future-unknown.

Chicagology. "Sears, Roebuck & Co. Building." Accessed April 15, 2018. https://chicagology.com/centuryprogress/1933fair15.

Chicago Tribune. "Sears Tower: What the Pedestrian Will See." October 11, 1970.

———. "Tower to Withstand High Wind." August 30, 1970.

Christian, Sue Ellen. "Sears Drawing a Crowd at New Site." *Chicago Tribune* (online), March 10, 1993. Accessed June 1, 2018. http://articles.chicagotribune.com/1993-03-10/news/9303190883_1_sears-tower-sears-merchandise-group-real-estate.

Collin, Dorothy. "Pioneers Land at Sears Tower." *Chicago Today*, September 11, 1973.

"Cultural Affairs and Special Events." City of Chicago: Public Art Program > *I Will*. June 15, 2018. www.cityofchicago.org/city/en/depts/dca/supp_info/chicago_s_publicartellsworthkellysiwill.html.

DeKlerk, Jo Ann. E-mail correspondence and personal interview with the author. April–May 2018

D'Eramo, Marco. *The Pig and the Skyscraper: Chicago: A History of Our Future*. New York: Verso, 2003.

Emmet, Boris, and Jeuck, John E. *Catalogues and Counters: A History of Sears, Roebuck & Company*. Chicago: University of Chicago Press, 1965.

Encyclopedia of Chicago. "Century of Progress Exposition." Accessed June 1, 2018. http://www.encyclopedia.chicagohistory.org/pages/225.html.

———. "Sears, Roebuck & Co." Accessed June 1, 2018. http://www.encyclopedia.chicagohistory.org/pages/2840.html.

Enstad, Robert. "Girder Tops Sears 'Rock.'" *Chicago Tribune*, May 4, 1973.

Enstad, Robert, and Frank Haramija. "Sears Tower Blaze Fatal to Four Workers." *Chicago Tribune*, April 12, 1973.

Fitzgerald, Kate. "Sears, Ward's Take Different Paths in the Burgeoning Postwar Years; A Gamble Pays Off for the General." *Ad Age*, July 31, 1995. Accessed June 1, 2018. http://adage.com/article/news/sears-ward-s-paths-burgeoning-postwar-years-a-gamble-pays-general/86197.

Goldsborough, Bob. "Richard C. Halpern, 1933–2011." *Chicago Tribune*, July 11, 2011. http://articles.chicagotribune.com/2011-07-11/news/ct-met-halpern-obit-20110711_1_building-projects-willis-tower-tallest-building.

Green, Larry, and Tracy Shryer. "Sears to Move Core Group to Chicago Suburb." *Los Angeles Times*, June 27, 1989. Accessed June 1, 2018. http://articles.latimes.com/1989-06-27/business/fi-4459_1_sears-tower-merchandising-group-chicago-suburb.

Greene, Nick. "The Man Who Saved the Skyscraper." *Mental Floss Magazine* (July/August 2016). https://mentalfloss.atavist.com/the-man-who-saved-the-skyscraper.

Harris, Melissa, and Dan Hinkel. "What Went Wrong with the Sears' Business Park in Hoffman Estates?" *Chicago Tribune* (online), November 20, 2011. Accessed June 1, 2018. http://articles.chicagotribune.com/2011-11-20/business/ct-biz-1120-sears--20111120_1_sears-and-kmart-stores-sears-headquarters-business-park.

Horowitz, Louis J. *The Towers of New York*. New York: Simon and Schuster, 1937.

Illinois Business Hall of Fame. *Robert Wood: Montgomery Ward & Co*. Macomb: Western Illinois University, 2016.

Kamin, Blair. "Calder's 'Universe' Sculpture Not Part of Willis Tower Renovation." *Chicago Tribune*, February 1, 2017. http://www.chicagotribune.com/news/columnists/ct-willis-tower-sculpture-kamin-met-0201-20170201-story.html.

Keats, Nancy. "Sears Vintage Kit Homes Now Sell for More than $1 Million." *Wall Street Journal*, September 21, 2017. https://www.wsj.com/articles/some-vintage-kit-homes-now-sell-for-over-1-million-1506001728.

Kiplinger's Personal Finance. Google Books. Accessed June 1, 2018.

Maclean, John N., and James Coates. "Sears' Bells Tolling for Donnelley Plant." *Chicago Tribune* (online), January 29, 1993. Accessed June 1, 2018. http://articles. chicagotribune.com/1993-01-29/business/9303173838_1_donnelley-plant-catalog-job-losses/2.

Marx, Donna. "Sears Tower—Symbol of Faith in the City." *Chicago Today*, May 2, 1973.

Mooney, Andrew J. "Sears Roebuck and Co. District: Final Landmark Recommendation Report." Commission on Chicago Landmarks, December 4, 2014. https:// www.cityofchicago.org/content/dam/city/depts/zlup/Historic_Preservation/ Publications/Sears_Roebuck_and_Co_District.pdf.

Mr. Sears Catalog. Documentary. WGBH Educational Foundation. https://www. youtube.com/watch?v=Dyx4WzcND14.

Nagelberg, Alvin. "Sears Tower: New Heights of Design." *Chicago Tribune*, August 2, 1970.

Nickerson, Matthew. "When Sears, the Facebook of Its Era, Launched Its IPO." *Chicago Tribune*, May 12, 2012. Accessed June 1, 2018. http://www.chicagotribune. com/ct-per-flash-sears-ipo-0513-20120513-story.html.

"Population History of Chicago from 1840–1990." Series and Parallel Circuits. Accessed June 1, 2018. http://physics.bu.edu/~redner/projects/population/ cities/chicago.html.

Preservation Chicago. "Calder's The Universe Sculpture at Willis Tower Disassembled with Future Unknown." Accessed May 1, 2018. https:// preservationchicago.org/newsletter_posts/calders-the-universe-sculpture-at-willis-tower-disassembled-with-future-unknown.

Redner, Sydney. "Population History of Chicago from 1840–1990." Boston University. http://physics.bu.edu/~redner/projects/population/cities/chicago.html.

Reich, Peter. "Calder Views the Challenge—Sears Lobby." *Chicago Tribune*, November 1, 1973.

"Richard C. Halpern, Oversaw Construction of the Willis Tower, Dies at 78." *Chicago Tribune* (online), July 11, 2011. Accessed June 1, 2018. http://articles. chicagotribune.com/2011-07-11/news/ct-met-halpern-obit-20110711_1_ building-projects-willis-tower-tallest-building.

Rivera, Mark. "Final Chicago Sears Store Starts Liquidation Sales." ABC7 Chicago. April 27, 2018. Accessed June 1, 2018. http://abc7chicago.com/business/final-chicago-sears-store-starts-liquidation-sales/3400079.

Rydell, Robert. "Century of Progress Exposition." Encyclopedia of Chicago. Accessed April 23, 2018. http://www.encyclopedia.chicagohistory.org/ pages/225.html.

Schmich, Mary. "MLK's Legacy in Lawndale a Work in Progress." *Chicago Tribune*, January 28, 2016. Accessed June 1, 2018. http://www.chicagotribune.com/ news/columnists/schmich/ct-lawndale-martin-luther-king-mary-schmich-met-0126-20160126-column.html.

Sears Archives. "Craftsman." http://www.searsarchives.com/brands/craftsman.htm.

———. "Irving Park Store." http://www.searsarchives.com/stores/history_chicago_irving.htm.

———. "Julius Rosenwald (1862–1932)." Accessed June 1, 2018. http://www.searsarchives.com/people/juliusrosenwald.htm.

"Sears, Roebuck & Co." *Ad Age*. September 15, 2003. Accessed June 15, 2018. https://adage.com/article/adage-encyclopedia/sears-roebuck/98873.

Shaffer, Terry. "Hardhats Climax Sears Top-out with All-out Brawl." *Chicago Daily News*, May 4, 1973.

Skyscraperdefense. "Skyscraperman A.k.a. SpiderDan Scales Sears Tower with Spider-Man's Stan Lee Interview." YouTube, January 13, 2009. Accessed June 1, 2018. https://www.youtube.com/watch?v=woD6DVOBNvU.

Solonickne, Lara. "Sears Homes of Chicagoland." Accessed May 22, 2018. http://www.sears-homes.com.

Sozzi, Brian. "20 Reasons Why Sears Is the Worst Stock in the World." The Street, February 2, 2016. Accessed June 1, 2018. https://www.thestreet.com/story/13444692/1/20-reasons-why-sears-is-the-worst-stock-in-the-world.html.

Stevenson, Katherine Cole, and H. Ward Jandl. *Houses by Mail: A Guide to Houses from Sears, Roebuck and Company*. New York: John Wiley & Sons, 1986.

"Stores Top Retailers 2016." National Retail Federation. June 30, 2016. Accessed June 1, 2018. https://nrf.com/resources/annual-retailer-lists/top-100-retailers/stores-top-retailers-2016.

Strom, Stephanie. "Sears Eliminating Its Catalogues and 50,000 Jobs." *New York Times*, January 26, 1993. Accessed June 1, 2018. https://www.nytimes.com/1993/01/26/business/sears-eliminating-its-catalogues-and-50000-jobs.html.

Thornton, Rosemary. *The Houses that Sears Built: Everything You Ever Wanted to Know About Sears Catalog Homes*. 2nd ed. Alton, IL: Gentle Beam Publications, 2004.

Weil, Gordon L. *Sears, Roebuck, U.S.A.: The Great American Catalog Store and How It Grew*. New York: Stein and Day, 1977.

"When Sears Shared." Inequality.org. Accessed June 1, 2018. https://inequality.org/great-divide/sears.

Wiggins, Hilda. Letter and interview with the author, May 9, 2018.

WLS History. "The WLS National Barn Dance." Accessed May 12, 2018. http://www.wlshistory.com/NBD.

Worthy, James C., *Shaping an American Institution: Robert E. Wood and Sears, Roebuck*. Champaign: University of Illinois Press, 1984.

Would You Buy a Home from Sears? These People Did and They Love It. Documentary. *Washington Post*. https://www.youtube.com/watch?v=0bxxHoT2rk4&t=120s.

INDEX

A

A.C. Roebuck Company 28
Alcoa Aluminum 107
Allstate 93, 109
American Bridge 107, 109, 110, 111, 114, 117, 127
Aurora 56, 85
Avery, Sewell 70, 84

B

Batavia 85
Baxter, Howard 114, 127
Berwyn 85, 146
Bloomingdale 85
Bolingbrook 85
Bourbonnais 85
Brennan, Edward 141, 142, 143, 149
Bridgeview 85
Brown, Leroy 135, 136
Burnham, Daniel 20, 131

C

Calder's *The Universe* 134, 154
"Century of Progress" World's Fair 78
Chicago Ridge 85
Chinn, Philip 85, 102, 104, 105, 126, 135, 136
Craftsman 91
Crowell, David 110, 132
Crystal Lake 85

D

Daley, Richard J. 126, 127, 131, 150, 157
Darien 85
DeKlerk, Jack 110, 114, 124, 126, 138
DeKlerk, Jo Ann 110, 114, 124, 126, 127, 128
Des Plaines 30, 56
Die-Hard 88
Downers Grove 56, 146

E

Eck, Marcell 114, 118
Elgin 56, 85
Elmwood Park 85
Environetics 102, 133, 140

F

Fox Lake 85, 146
Fulton Market 40, 45

G

Glen Ellyn 56
Goodwin, Dan 136
Graham, Bruce 103, 105, 106, 107, 137
Great Works 35, 40, 47, 55, 72, 97,
 102, 103, 111, 127, 132, 133,
 149
 Administration Building 43
 Merchandise Building 43, 44, 45
 Merchandise Development and
 Laboratory (MDL) Building 43
 Power House 43
 Printing Building 43
 "Sears tower" 44
Gumber, Richard "Dick" 117, 118,
 119, 127
Gurnee 85

H

Halpern, Richard 107, 108, 109, 111,
 113, 142

Hoffman Estates 85, 141
Hoffmanl, David 109, 119, 123
Homan Arthington Foundation 150
Homart Development Company 85
Horowitz, Louis J. 42, 43, 45
Hunter, Rebecca 51, 56

I

Ironworkers Local Union #1 107
Itasca 56
Iyengar, Hal 108, 113

J

John Hancock Center 105, 109, 136
Judd, Bob 35, 157

K

Kenmore/Coldspot 88
Kettleston, Walter 122, 138
Khan, Fazlur 105, 106, 137
King, Martin Luther King, Jr. 103

L

Lake Zurich 85, 146
Lawndale 42, 103, 149
Libertyville 56
Loeb, Arthur 42
Lombard 56
Lucas, Larry 122, 138

M

Martinez, Arturo "Arthur" 144
Mele, Dennis 15, 147, 157, 158
Melrose Park 85, 123
Mercy Housing Lakefront 150
Metcalf, Gordon 102
Montgomery Ward 25, 28, 47, 51, 70, 72, 84, 147
Mugica, Vic 117

N

Naperville 85
Niles 85
Nimmons, Carr & Wright 55
Nimmons, George C. *See* Nimmons, Carr & Wright
North Riverside 85

O

Oak Brook 85
Olson, Leonard 122, 138
Oswego 85

P

Petronas Towers 101
Porzuczek, John 114, 115, 117, 118, 124, 125, 126, 128, 131, 158
Prairie Stone 142, 143, 155, 156
profit-sharing 35, 96

R

Roebuck, Alvah Curtis 25, 30, 80
Rosenwald, Julius 33, 35, 40, 42, 43, 45, 47, 55, 64, 70, 72, 73, 78, 93, 96
Rowell, Scott 114, 115, 121
R.R. Donnelley & Sons 43, 146

S

Sears Catalog 28, 33, 64, 83, 144, 146
Sears Modern Homes 50, 54, 63, 83
Sears retail stores
 62nd and Western Avenue 73, 149
 79th Street 73, 149
 Englewood 80, 149
 Galewood/Elmwood Park 83, 149
 Lawrence Avenue 73, 149
 Portage Park (Six Corners) 13, 82, 149
 State Street 74, 149
Sears, Richard Warren 19, 22, 25, 30, 32, 47
Sears-Roebuck Foundation 25
Sears Tower 14, 101, 103, 106, 107, 109, 111, 113, 114, 115, 119, 121, 123, 126, 132, 133, 134, 135, 136, 137, 139, 140, 154, 158
Skidmore, Owings & Merrill LLP 105
Solonickne, Lara 54, 55, 56
Stack, Tommy 119, 128
St. Charles 85
Streamwood 85

T

Thompson-Starrett 42
Thornton, Rosemary 63
Tinley Park 85, 155
Tomlinson, Richard 109, 134
Towery, Earl 121

V

Vernon Hills 85
Villa Park 54, 56

W

Walmart 140, 144
Walsh, William 122, 123, 138
Waukegan 56, 85
Wiggins, Amy 158
Wiggins, Hilda 122, 123, 158
Wiggins, Robert 122, 123, 138
WLS 64, 69, 70, 155
Wood, General Robert E. 70, 72, 73,
 84, 85, 93, 96, 140, 147, 148
Woodstock 56, 80
World Trade Center 106, 108
Worley, Ray 111

Z

Zils, John 105, 119

ABOUT THE AUTHOR

Val Perry Rendel is a Chicago-area writer whose parents met while working at Sears headquarters in the 1960s. She has a PhD in English and spent eighteen years teaching college writing before deciding that "Those who can, do." Now she spends her days unpacking the secret stories of people, places and things.

The author on the 103rd floor observation deck of the Sears Tower, August 18, 1980.